IMAGES
of America

HURON COUNTY
MICHIGAN

Huron County Historical Society

ARCADIA

First Printed 2001
Reprinted 2004

Published by Arcadia Publishing,
Charleston SC, Chicago IL, Portsmouth NH, San Francisco CA

Printed in Great Britain.

Library of Congress Catalog Card Number: 2001093325

For all general information contact Arcadia Publishing at:
Telephone 843-853-2070
Fax 843-853-0044
E-Mail sales@arcadiapublishing.com

For customer service and orders:
Toll-Free 1-888-313-2665

Visit us on the internet at http://www.arcadiapublishing.com

This book is dedicated to the memory of

Tony Fisher

whose interest in the preservation of history in the Port Austin area has been of great significance to all of us and especially to the content of this book.

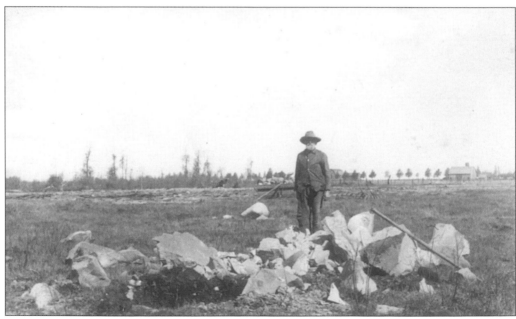

From the 1880s until today, agriculture remains Huron County's prime economic mover. In this scene around 1920, George Willett is clearing rocks as the last step in preparing a new field.

CONTENTS

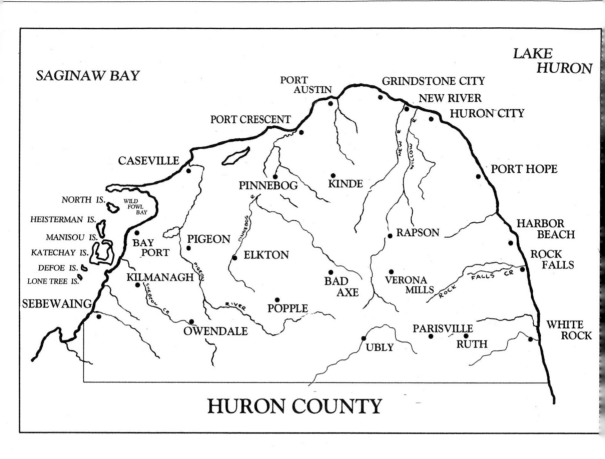

HURON COUNTY

Huron County is situated in the Thumb of Michigan.

INTRODUCTION

Huron County is located at the tip of the area known as the Thumb of Michigan, due to the state's unique mitten-like shape. French maps of the Great Lakes around 1660 suggest that French explorers had entered the area to trade with the Sauk and Fox Tribes living there at the time. The region remained a part of New France until the Treaty of Paris at the end of the French and Indian Wars in 1763, when it was ceded to the British. For a period of time, what is now Huron County (along with the northernmost parts of Michigan) was granted to the Colony of Virginia by the British Crown. In 1784, all of what would become the Thumb of Michigan became part of the United States' Northwest Territory under the Articles of Confederation. However, the British remained in control of the lower Great Lakes until Perry's Victory at Put-in-Bay in 1813, during the War of 1812. By 1819, the Treaty of Saginaw brought the Indians in the region under United States authority and the Thumb area was finally open to settlement along the shores of Lake Huron and the Saginaw Bay.

Huron County was organized by the Michigan legislature in 1859, with the original courthouse located in Sand Beach (Harbor Beach). This courthouse burned in 1864 along with all the records. The county seat was moved to Port Austin in 1865. After a few years, County officials decided a more central location was needed; and, in October of 1873, the county seat was moved to Bad Axe. By mid-1876, a new three-story masonry courthouse was completed and served the county for more than 90 years.

In the beginning, Huron County was covered with great forests that had both hardwoods and evergreens in around 100 different species. Soon, many lumber camps and lumber mills were busy cutting and clearing the forests. Records kept in 1873 show that over 80 million board-feet of lumber were produced that year alone. Pine planks of record size were cut at Verona Mills in 1876 that measured 16 feet long, five feet in width, and four inches thick without any knots or flaws. They were exhibited in Philadelphia in 1876 at our Country's Centennial Celebration.

The summer of 1881 had been especially dry and hot. The lumbering industry had left a considerable amount of slash (the treetops and limbs not used for lumber) in its wake. Moreover, there was acre upon acre of dead wood left from the forest fires that raged through the tops of the trees ten years before. Many settlers were clearing their land by burning the dead wood and slash. A sudden increase in wind caused many small fires to go out of control and

merge into larger fires and then into one huge inferno. The giant wall of flame moved eastward across the county faster than horses could gallop. The sky became as dark as night and many people thought it was the end of the world. In Bad Axe, they hurried to the new courthouse which was the only masonry building in the town. Soon the courthouse was filled with weeping women, crying children, and the injured. The men formed bucket brigades to douse embers on the roof. Bad Axe was almost completely destroyed, as were many other towns in the county, but the people in the courthouse survived. The fires raged on until they reached Lake Huron. It is said that many animals, wild and domestic, stood together with people in the lake to escape the flames. It is estimated that as much as 1,500 square miles, from Saginaw to Lake Huron, were consumed in the three to four days that the fires raged, and hundreds of people died.

The county was a tragic scene with only a few isolated buildings spared in the path of the fire. The newly formed Red Cross gave relief to its first disaster when it arrived to help the victims. Other help poured in from many sources. Soon, these brave and courageous pioneers were busy rebuilding. It was September and winter was soon to come.

Rapid development followed in the wake of the fires. The coming of the railroads in 1882 and the years following brought many new residents. Realtors were advertising land cleared by fire at $1.25 an acre. New settlers from Canada, New York, and states to the south came to Huron County in great numbers. By 1900, many rural schools were in operation and over 100 post offices, most located in general stores, were serving the county.

The Great Fire of 1881 had cleared the way for Huron County to become one of the leading agricultural areas in the state. Today, the major crops are corn, navy beans, sugar beets, wheat, alfalfa, oats, soybeans, and barley. Major enterprises also include dairy, livestock, and poultry production. Commercial fishing has also been important, with Bay Port once having been the fresh-water fish capital of the world. Numerous manufacturing facilities have developed throughout the county. Bad Axe and Harbor Beach are now its two largest cities. There are nine villages and numerous named communities with no organized local governments. Ninety miles of beautiful shoreline have brought many summer residents and tourists to enjoy the cool, clean lake air and to avail themselves of the ever-growing sport fishing community.

Huron County has come a long way since its early settlements along the shoreline in pioneer log cabins. Many museums throughout the county preserve this heritage so the pioneer days will not be forgotten by the generations to come.

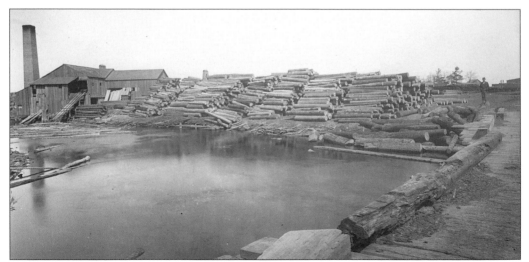

Lumbering was an early industry in Huron County. The old sawmill pictured here was located in Caseville and burned in August of 1908. It was located where Hoy's Saginaw Bay Marina stands today.

One

BAD AXE

The city of Bad Axe received its unique name in 1861, when a survey party led by Rudolph Papst was locating a route through the wilderness for a state road from Sand Beach (now Harbor Beach) to Sebewaing. They stopped nights at old campsites. At a camp about halfway along the route, they found an axe with a broken handle and a jagged blade. A notation was made on the survey chart "bad axe camp." It became the name of the settlement that eventually became the city of Bad Axe. In 1873, being centrally located, Bad Axe was designated the county seat. By 1875, a fine, three-story masonry courthouse was constructed at a cost of $25,000. In 1881, the terrible forest fire destroyed most of the Thumb area. The new courthouse was the only masonry building and so became a place of refuge for survivors and the many injured. The clearing of the land by fire for agriculture brought in new settlers. Railroad service from Port Huron in 1882 soon increased the population from 170 people to almost 500. Progress gained momentum with the incorporation as a village in 1885. A water system was established in 1894; electric lighting in 1897; and incorporation as a city in 1905. A city sewer system was completed in 1917 and a new masonry post office building was erected in 1919. Bad Axe continues to grow —with fine schools, a library, museums and parks, healthcare facilities, churches, industrial areas, shopping downtown and at new malls, many restaurants, and more. The population has now grown to 3,500.

Rudolph Papst is believed to have named Bad Axe while conducting a survey for the early road from Sand Beach to Sebewaing in 1861. He found an axe lodged in a stump with a broken handle near the town's present location, and dubbed the spot the "Bad Axe Camp." It later became the Bad Axe Corners, was incorporated as the village of Bad Axe in 1885, and as a city in 1905.

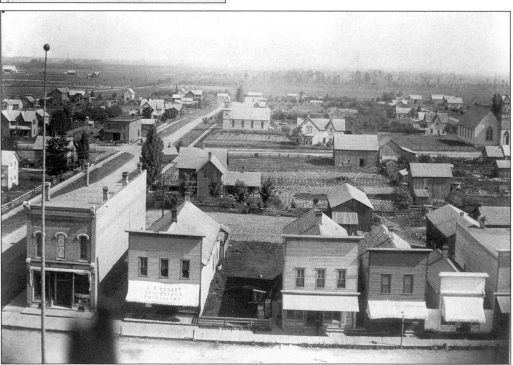

This is Bad Axe as seen in 1892, looking north from the cupola atop the old Courthouse on East Huron Street. The first street to the north is Woodworth and the street running north on the left is Heisterman. All of the streets in town are dirt and Huron Avenue has wood sidewalks in front of the stores.

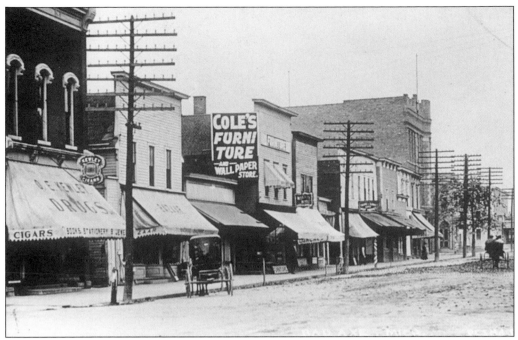

This view of downtown Bad Axe in 1908 shows the second block along East Huron Avenue.

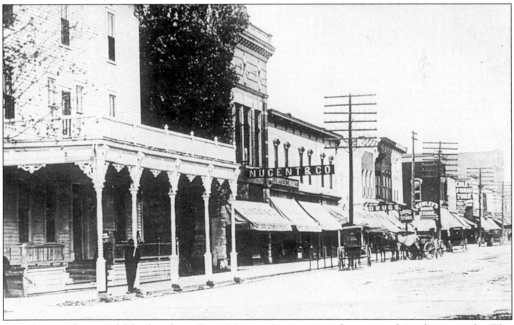

The first and second blocks along East Huron Avenue are shown in this photograph. The Irwin House hotel, on the left, was located at the corner of Huron Avenue and North Port Crescent Street.

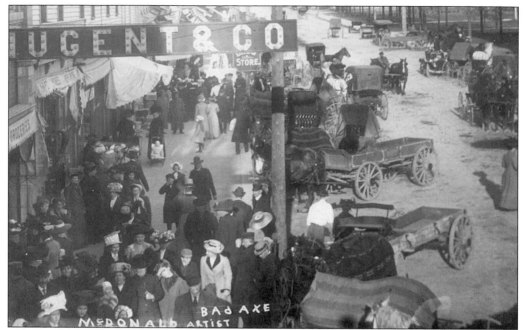

This is the Nugent General Merchandise Store, as it appeared on the day of its grand opening. By this time, the wooden sidewalk had been replaced with concrete, but Huron Avenue was still unpaved.

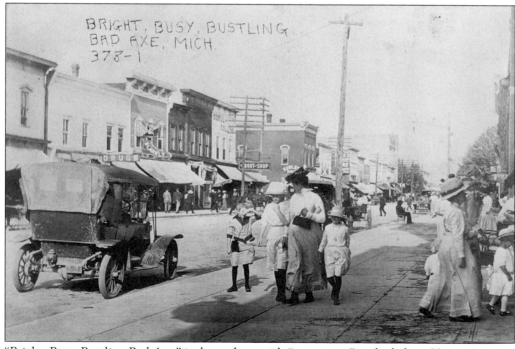

"Bright, Busy, Bustling Bad Axe" is shown here with "motor cars" parked along Huron Avenue.

12

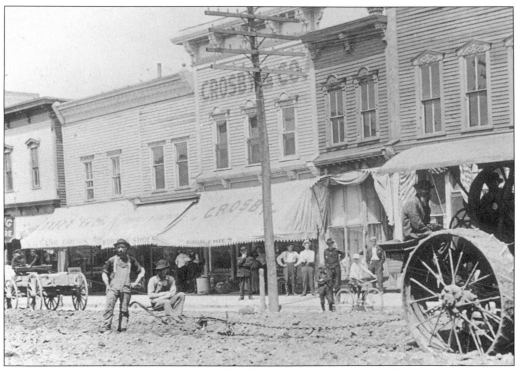

In 1909, Huron Avenue became one of the first paved streets in Michigan. Here, a steam tractor is used to plow the street in preparation for paving. All work has stopped momentarily while the photograph is taken. The south side of Huron Avenue is shown in the background.

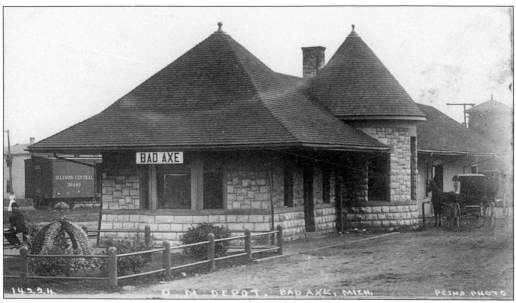

The Pere Marquette train station is shown here in 1911. The Port Huron & Northwestern Railroad first came to Bad Axe in 1882. The Saginaw, Tuscola, and Huron Railroad Company completed rail service to Saginaw in 1886. The P.H. & N.W. was acquired by the Pere Marquette Line and later the Chesapeake & Ohio Railway.

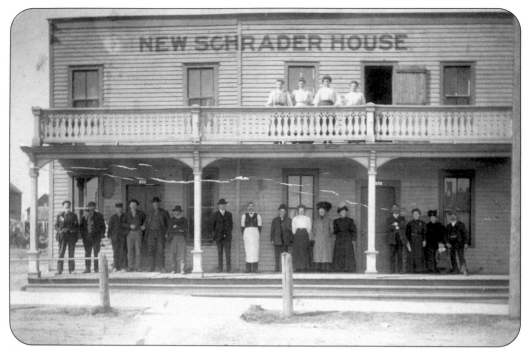

The Shrader House Hotel was located across the street from the Pere Marquette Train Depot. Later, it became known as the East End Hotel.

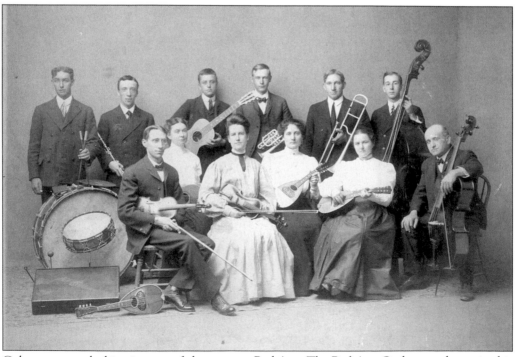

Culture was not lacking in turn-of-the-century Bad Axe. The Bad Axe Orchestra, shown in this 1903 photograph, presented a series of concerts each season. There were also glee club and drama groups who performed.

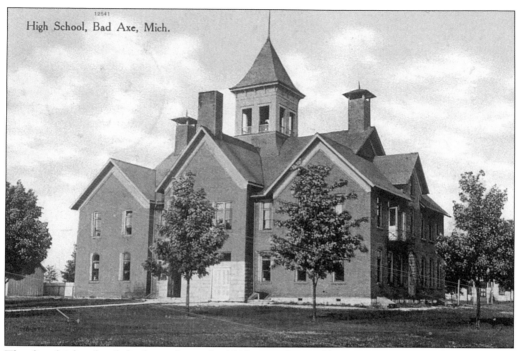

High School, Bad Axe, Mich.

The first high school, built in the early 1890s, was located between Hopson and Woodworth Streets on Whitelam Street. It was destroyed by fire.

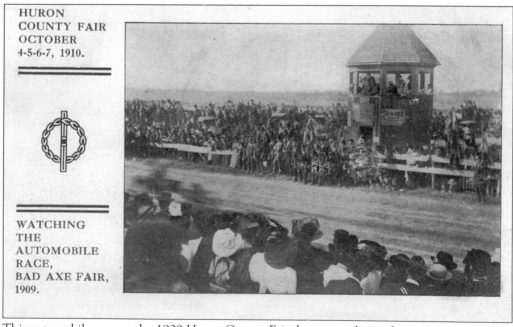

HURON
COUNTY FAIR
OCTOBER
4-5-6-7, 1910.

WATCHING
THE
AUTOMOBILE
RACE,
BAD AXE FAIR,
1909.

This automobile race at the 1909 Huron County Fair drew a good crowd.

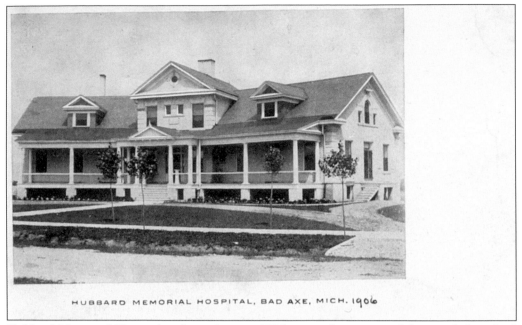

HUBBARD MEMORIAL HOSPITAL, BAD AXE, MICH. 1906

Hubbard Memorial Hospital is shown here in 1906, soon after it opened. It provided medical care for almost 50 years, when it was replaced by an up-to-date, much larger facility, which serves the Bad Axe area today.

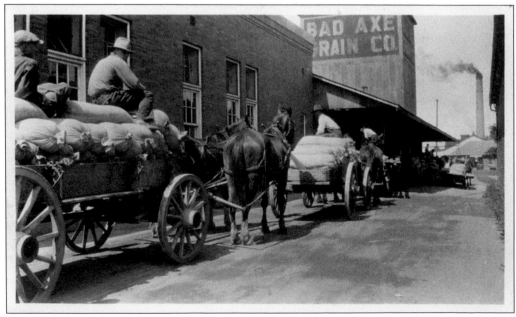

Grain wagons at harvest time are waiting in line to unload. This scene took place at the Bad Axe Grain Company elevator in 1925.

16

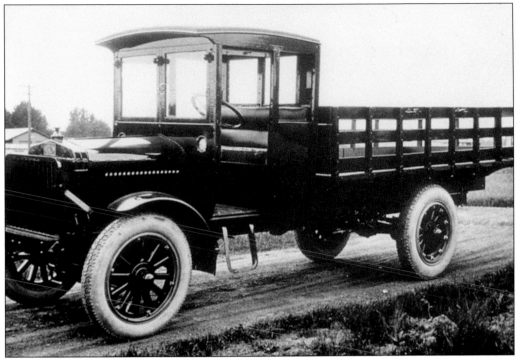

The Huron Truck was manufactured in Bad Axe from 1919 through 1921. Although the Huron Truck was said to be one of the best, the Huron Truck Company failed because of a recession.

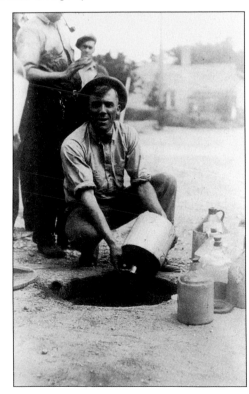

Deputy Duncan McKenzie is shown in 1920 enforcing the Prohibition Law as he dumps illegal whiskey into the sewer at the location where the "old city hall" now stands, at 110 Hanselman Street.

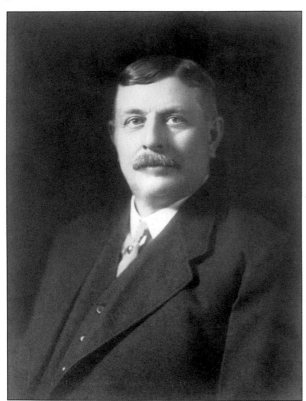

Albert E. Sleeper, the only governor from Bad Axe, served as governor of Michigan from 1917 through 1921. Among his accomplishments were the organization of the Michigan State Police and Michigan's State Park system.

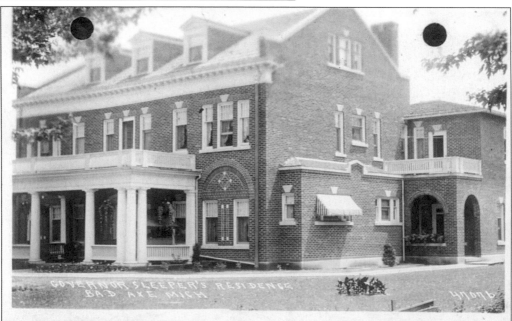

The impressive Sleeper mansion on West Huron Avenue was built in 1917 for $150,000. A portico at the eastside of the home protected visitors from rain or snow as they arrived or departed. A ballroom with crystal chandeliers was often used for parties and dances. This home is now the Weitenberner Funeral Home.

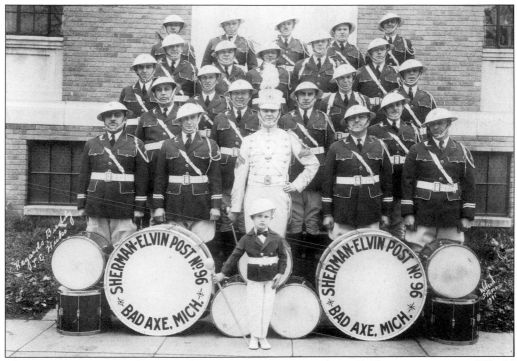

The American Legion Sherman-Elvin Post 96 was organized in 1920 by area veterans of World War I. Their Drum and Bugle Corps, shown here, won many awards in convention parades, notably in New York City and Chicago.

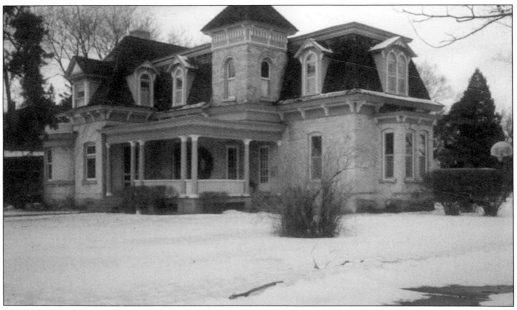

The Nugent house, built in 1890 by Septimus Irwin, was sold to merchant James Nugent and his wife. Ten children, a grandmother, and a live-in maid also resided there. This elegant home, located on West Hopson Street, is currently owned and occupied by the Dr. Timothy Straight family. It has recently been expertly restored and expanded.

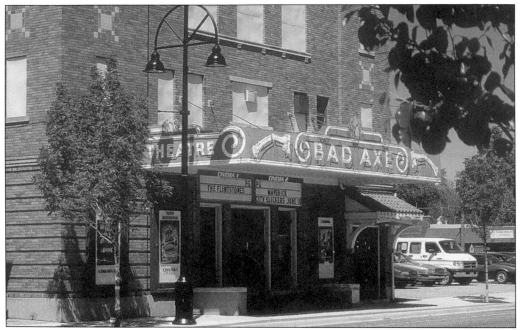

The Bad Axe Theater has operated for almost 80 years. In the beginning, silent movies were shown—accompanied by piano music. The "talkies" came in about 1928. Children enjoyed Saturday matinees showing Tarzan adventures, cowboy westerns, spooky movies, and comedies. Now, two screens show ultra-sophisticated films simultaneously, but the marquee with its broken axes is original. In the 1980s, it was used as a backdrop for a Buick Motor Division new vehicle advertising brochure.

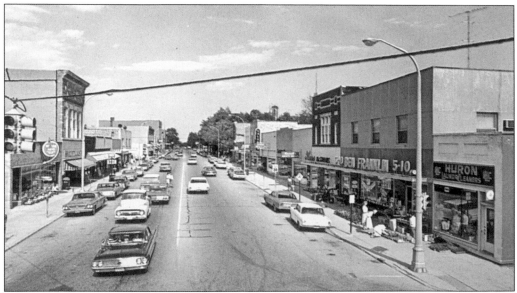

This is downtown Bad Axe in the 1960s, with wide paved streets and traffic moving smoothly (controlled by traffic lights) past modern storefronts. What a contrast to the "good old days," 100 or more years ago, when rutted dirt roads were traveled by horses pulling wagons or buggies. Let's not forget the past, so that we can appreciate the present.

Two
BAY PORT AND
ORA LABORA

Bay Port is located off of Wildfowl Bay, on the westside of Michigan's Thumb. In 1851, Carl Heisterman named the settlement Geneva, then it was changed to Switzerland, changed again to Wildfowl Point, and finally, when the post office at Ora Labora was moved to the shoreline, the community was named Bay Port. Fishing was responsible for the village's birth. Soon, the village of Bay Port became known far and near for its successful fisheries. It was rated as having the largest fresh water fisheries in the world. In 1880, Jesse Hoyt of New York began the Saginaw, Tuscola, and Huron Railroad. W.L. Webber ran the rail company and brought tourists to Bay Port from East Saginaw by the trainload in 1883 for rock hunting excursions. A 160-acre site, known as the Bay Port Quarry, was purchased and incorporated in 1900 by W.H. Wallace, George Morley, and A.H. Harvey. In 1886, Webber built a beautiful hotel in Bay Port. This facility contained 117 rooms with a casino, bowling, billiards, and electric lights. It was first class all the way. This grand hotel later became the Bay Port Club and survived until 1907, when it was torn down. Annually, the Bay Port Fish Sandwich Festival is held the first weekend in August, where thousands of fish sandwiches are sold. Another annual community event connected with the fishing industry, the Whitefish Boil, is held the third Sunday in May. Bay Port remains a wonderfully relaxing place to visit and the community is proud of its continuous fishing and hunting facilities.

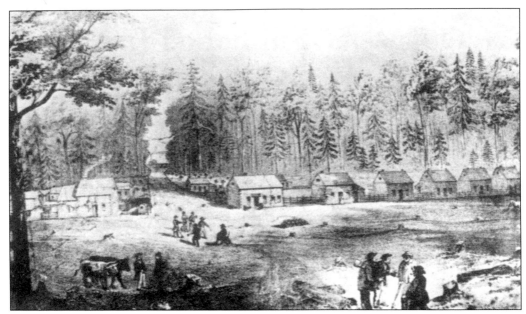

Ora Labora was established in 1862 as a communal colony. The name means "work and prayer". The group chose Emil Baur as its leader. By 1868, it was evident that the colony would not succeed. However, the colony brought many people to the area that remained to purchase land and start new businesses of their own.

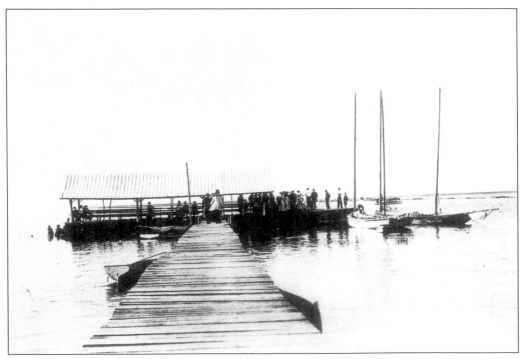

This is the old picnic pavilion as it appeared in 1900.

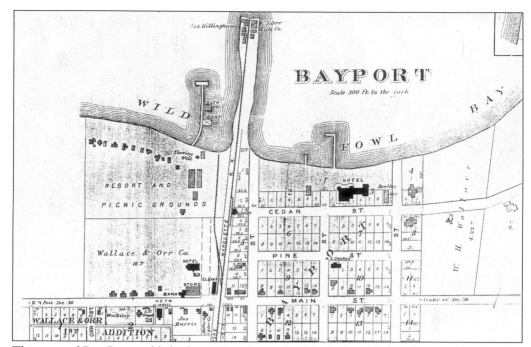

This map of Bay Port, published in 1904, shows the fish docks and shoreline involved in the recent DNR agreement with landowners in that area.

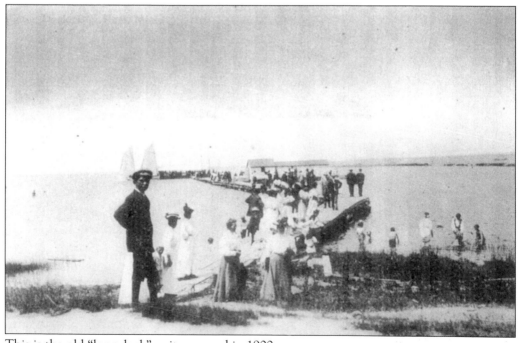

This is the old "long dock" as it appeared in 1900.

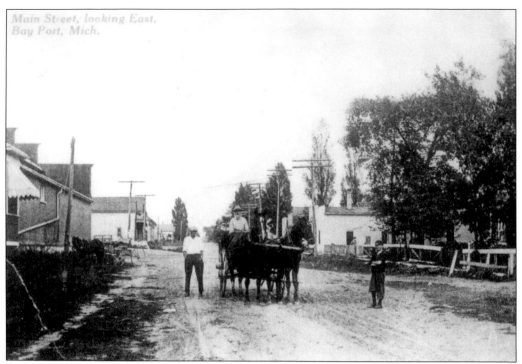

This is a view of Main Street looking east in 1900. Lee's Meat Market is on the right side of the street.

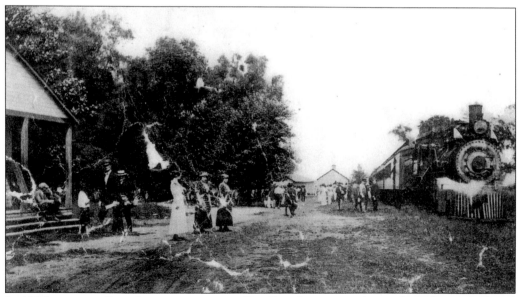

In 1905, many well-to-do tourists came to Bay Port by train and were brought to the hotel by carriage.

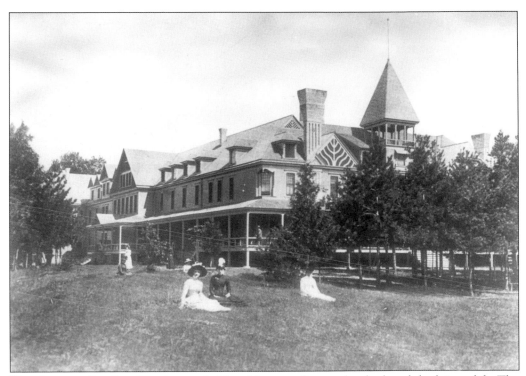

The glittering Bay Port Hotel was a fashionable resort for people who loved the leisure life. The hotel had electric lights on the main floor, making this one of the earliest uses of this "new" technology in Huron County. A gray, foot-worn stepping stone where the stage coach used to stop and a historical marker are all that remain of a man's once wonderful dream.

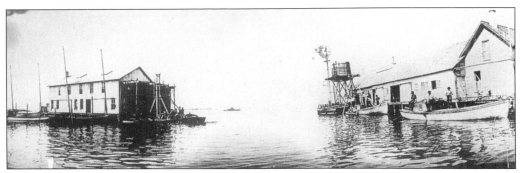

These are the fish buildings as they appeared about 1914. Notice the nets hanging alongside the twine houses and the fleet of sail boats used at that time for fishing.

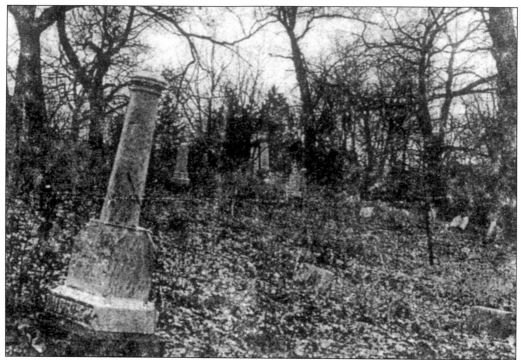

A cemetery full of worn headstones is all that remains of Ora Labora. This is the oldest cemetery in Huron County.

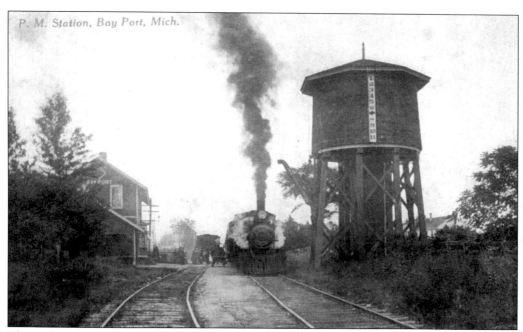

This is the Pere Marquette Train Depot and water tower in Bay Port.

This is how the Bay Port Quarry appeared in the 1890s. W.H. Wallace, George B. Morley and A.H. Harvey bought the operation in 1900 and incorporated it as the Wallace Stone Company. This is how quarrying went at various levels, with the deepest operations at about 40 feet.

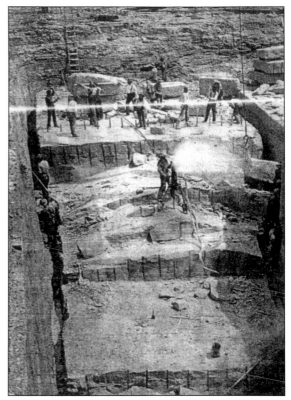

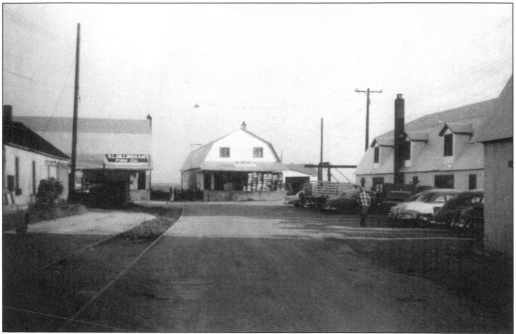

The Gillingham Fish Company was established in 1886 and the Bay Port Fish Company in 1895. In the 1920s and 1930s, the two companies shipped tons of perch, walleye, herring, and carp to New York and Chicago in refrigerated rail cars.

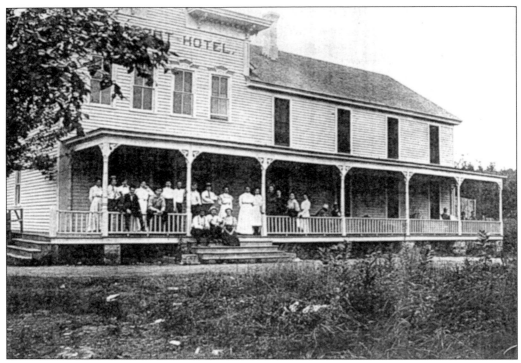

This is the Bay Port Hotel as it appeared in the early 1900s.

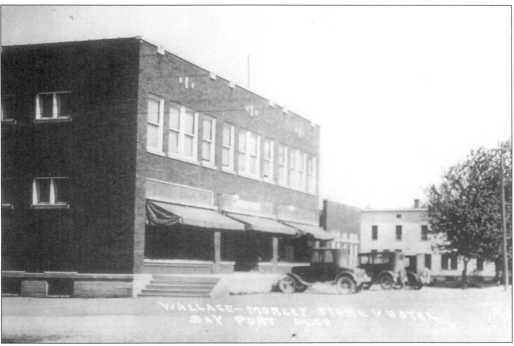

The Wallace & Morley Company store, Post Office, and the Hotel are shown here as they appeared in 1920.

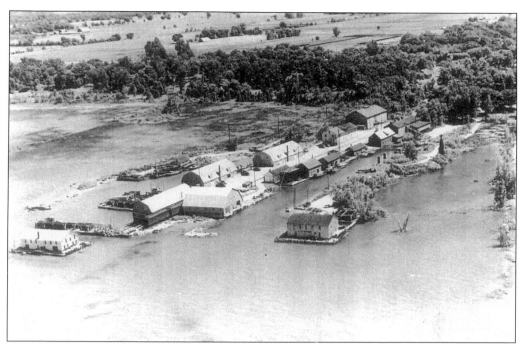

This is an overview of Bay Port's fish companies in the 1930s.

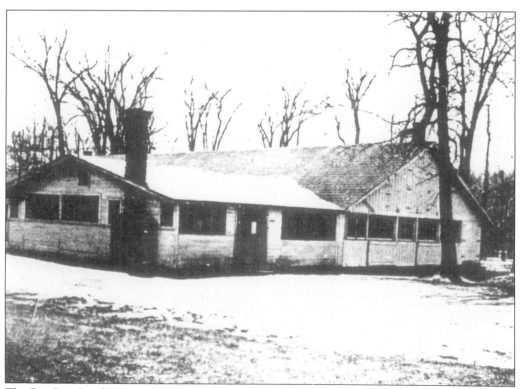

The Bay Port Pavilion was the most popular dance hall in the county during the 1930s and 1940s.

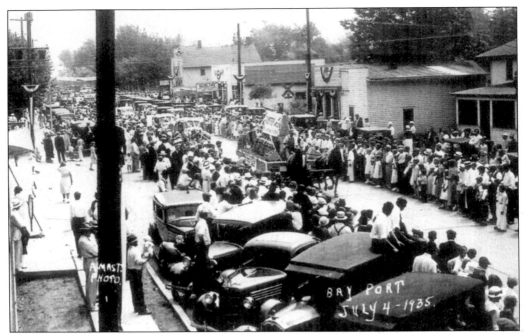

Bay Port was well known for its great parades. This one was on the Fourth of July in 1935.

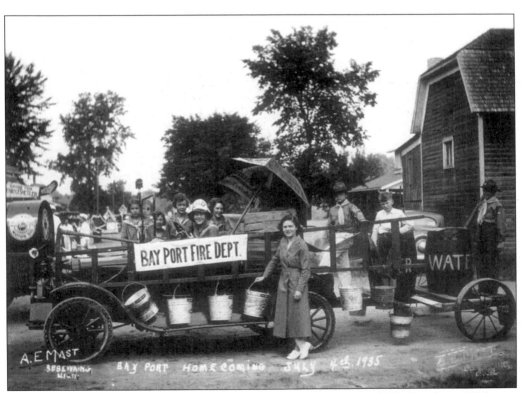

Here is the Bay Port Fire Department making ready for the Fourth of July Parade in 1935.

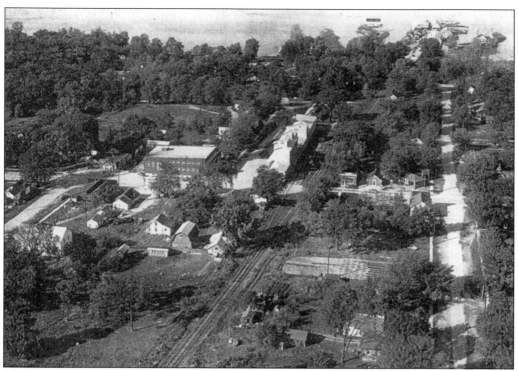

This photograph shows Bay Port in the 1950s.

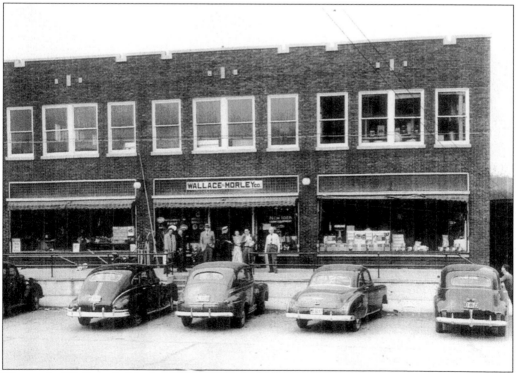

This is the Wallace & Morley Company as it appeared in the 1950s.

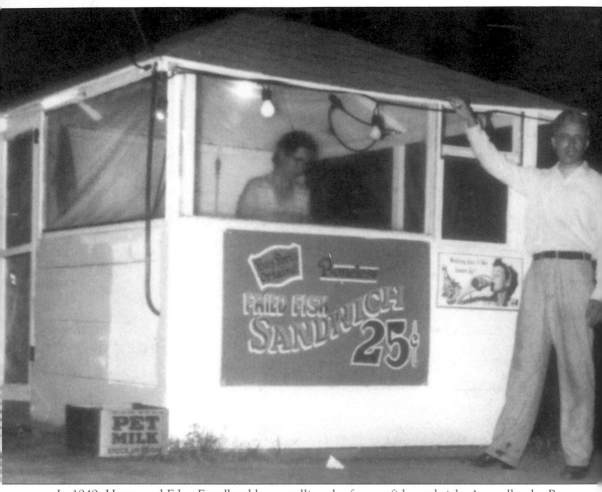

In 1949, Henry and Edna Engelhard began selling the famous fish sandwich. Annually, the Bay Port Fish Festival is held the first weekend in August, where thousands of fish sandwiches are sold.

Three
CASEVILLE

The area around Caseville was first occupied by Indians of the Chippewa Tribe. The first European settlers were Reuben Dodge, his wife, and his two children, who came from Maine in 1840. In 1856, twenty thousand acres were purchased by Francis Crawford from a Mr. Case of Cleveland, Ohio. The village of Caseville, originally called the Pigeon River Settlement, then Port Elizabeth, had many places of business, which included four or five general stores, a millinery, meat market, three hotels, a blacksmith shop, a wagon shop, and a shoe shop. In 1871, the annual production of three salt wells was from forty to fifty thousand barrels. Sawmills cut over three million feet of lumber annually. Caseville became a village in 1850. At that time it included what is now known as McKinley Township. In 1884, the people voted to establish two townships; the north half would become Caseville Township and the south half McKinley Township. The first Caseville Township Supervisor was Alexander Wheeler who served in 1860 and 1861. Francis Crawford served as supervisor in 1862 and 1863 and again from 1865 through 1867. Caseville had two docks to accommodate lake steamers and sailing vessels, which came regularly to bring goods and carry away the products of the town. In 1873, William McKinley Sr., father of President McKinley, owned and operated an iron works in Caseville and his son, later to become President McKinley, was a regular visitor to Caseville. In 1883, the Pontiac, Oxford, and Port Austin Railroad reached Caseville. The village of Caseville was incorporated on October 15, 1898; and the first village president was John Poss.

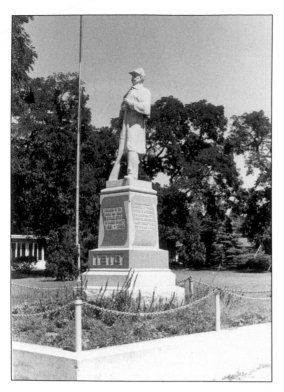

The Civil War Monument in Caseville is dedicated to the Living and Dead Soldiers of Huron County, 1861 to 1865. The Patriotic Citizens of Huron County erected it under the auspices of Nancy Smalley Circle No. 7, L of the Grand Army of the Republic. Five hundred and forty-three men who had lived in Huron County served in the Union Forces; forty-eight gave their lives.

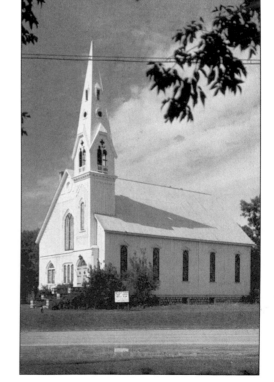

This is the Caseville United Methodist Church, built in 1874, and it is a Michigan Historical Site. The church's Gothic architecture is one of the oldest and most photographed in Michigan.

Francis Crawford is one of the founders of Caseville. He was elected the first Caseville Township Clerk on April 2, 1860. Crawford served as Caseville Township Supervisor in 1863 and 1864 and again in 1865 through 1867. Francis Crawford purchased 20,000 acres of land, which is now Caseville. He owned salt wells, a gristmill, a general supply store, a hardware store, and he manufactured lumber.

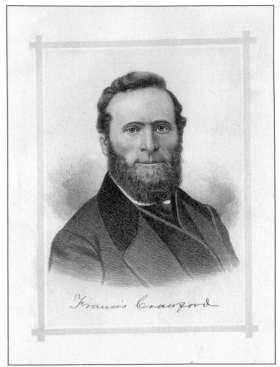

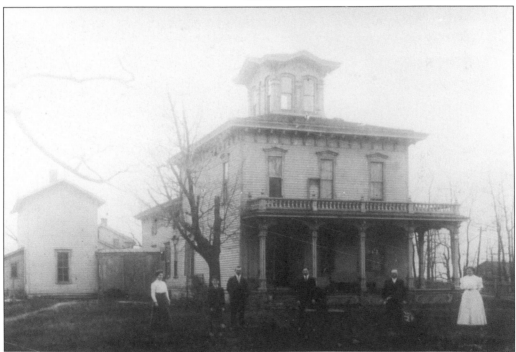

The mansion built by Francis Crawford on the Pigeon River bank in the 1850s has heavy walnut front doors with frosted glass from France. There is a square belvedere on top of the house. The Crawford house has been moved and is now the Champagne Funeral Home on Main Street in Caseville.

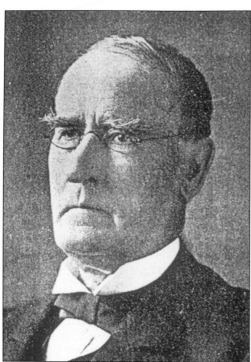

William McKinley Sr., father of President McKinley, owned and operated the iron works in Caseville in 1873.

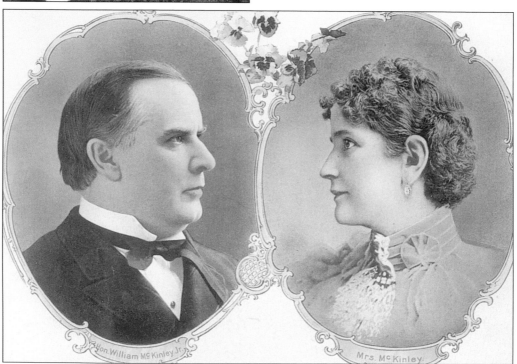

Hon. William McKinley Jr.

Mrs. McKinley.

President William McKinley and Ida Saxton McKinley are shown in this picture. President William McKinley Jr. was born January 29, 1843, to William McKinley Sr. and Nancy Campbell McKinley. He was inaugurated as the 25th President of the U.S. on March 4, 1897. President McKinley was assassinated in Buffalo, New York, on September 6, 1901.

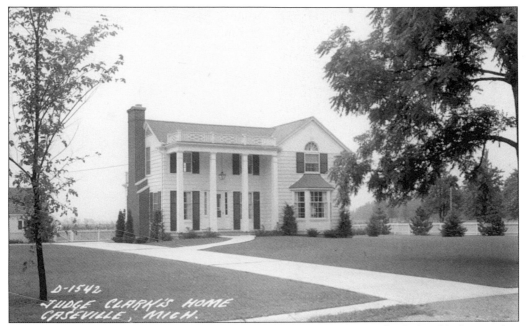

This is the home of Judge Clark at 6677 Michigan Avenue in Caseville. Judge Clark served as Justice of the Michigan Supreme Court from 1919 to 1933 and as Chief Justice from 1924 to 1932. This home is now owned by Dale Kretzschmer.

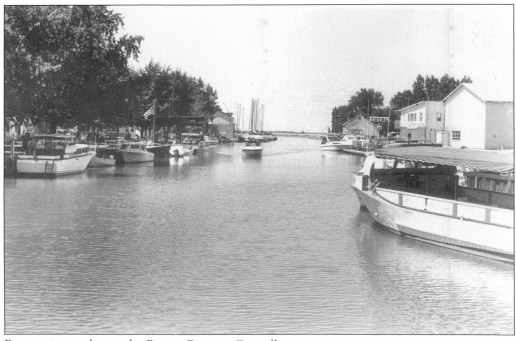

Boating is popular on the Pigeon River in Caseville.

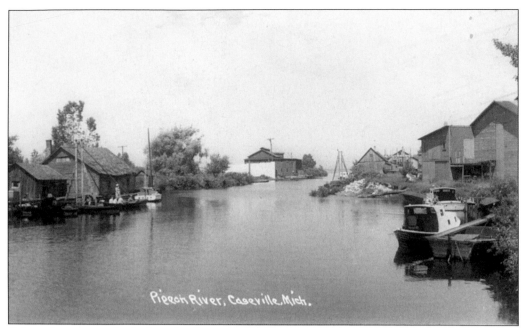

Fishing boats were docked on the Pigeon River in Caseville in 1930.

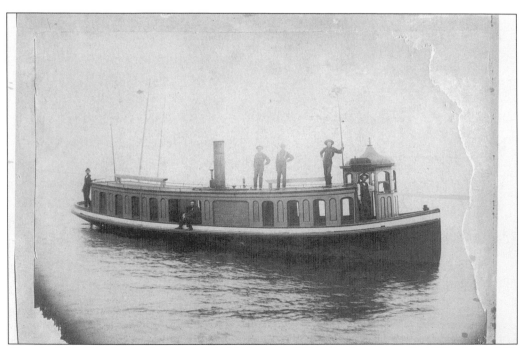

Captain E.H. Ditzel was the owner of this boat in 1885. On board are C. Gillingham, J.H. Gillingham, and J.E. Gillingham of Bay Port and Caseville.

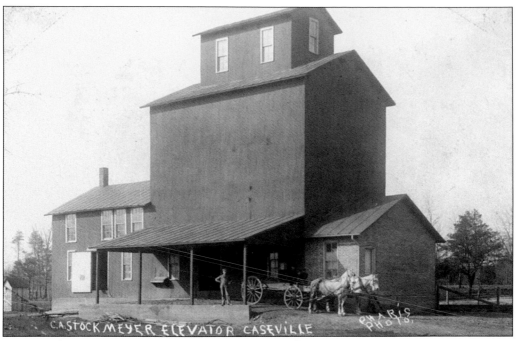

C.A. Stockmeyer owned this grain elevator in Caseville.

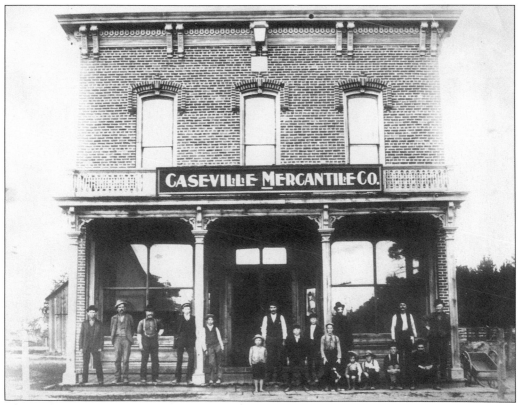

This is the Caseville Mercantile as it appeared in 1890.

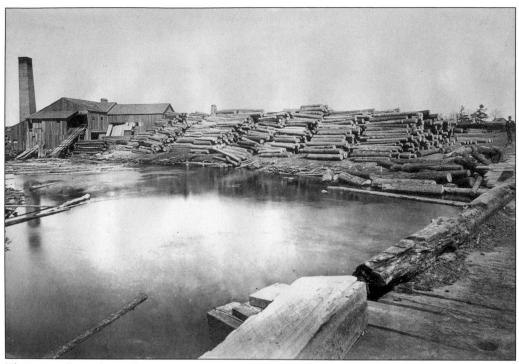

This sawmill was located in Caseville in the 1870s. The site is now Hoy's Saginaw Bay Marina.

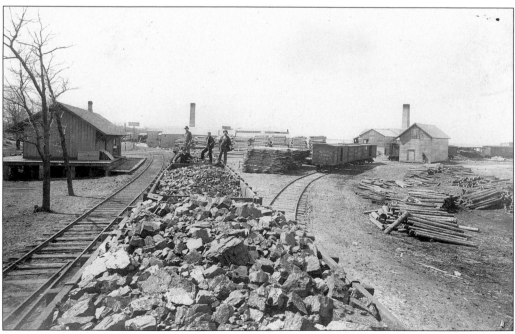

Lumber was shipped out of this railroad yard in Caseville at the turn of the century.

The Smalley Hotel was located in downtown Caseville.

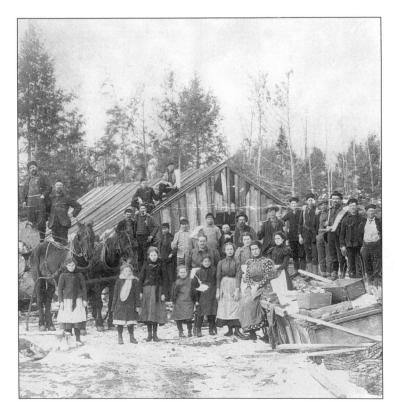

The Smith and Wilfong lumbering camp was located three and one-half miles northeast of Caseville.

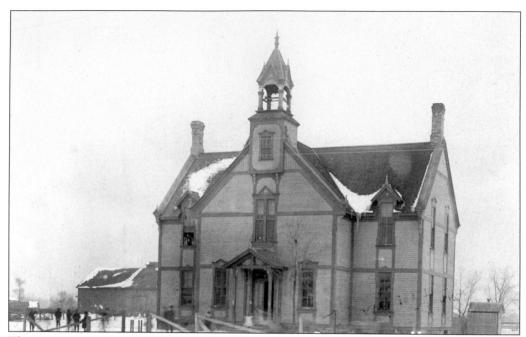

This is a picture of the old Caseville High School.

This award-winning photograph of Hoy's Saginaw Bay Marina was taken by Mildred Beadle on July 3, 1988.

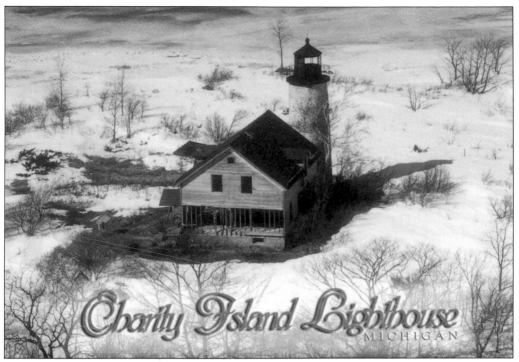

An old lighthouse is located on Big Charity Island in the middle of Saginaw Bay. The first lighthouse on the island was established in 1857. The light pictured here was extinguished in 1939, when the nearby Gravelly Shoal Lighthouse was put into service.

This toboggan slide was located at the corner of Main Street and County Park Road in Caseville, where the mobile-home park is located today.

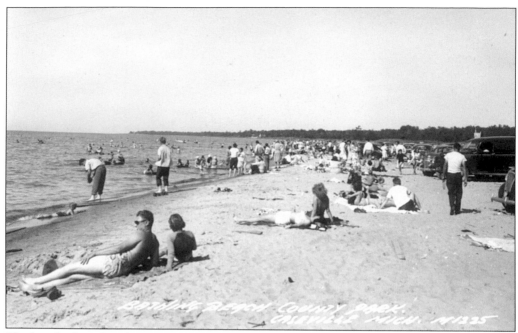

The best bathing beach in Huron County is located in the County Park in Caseville.

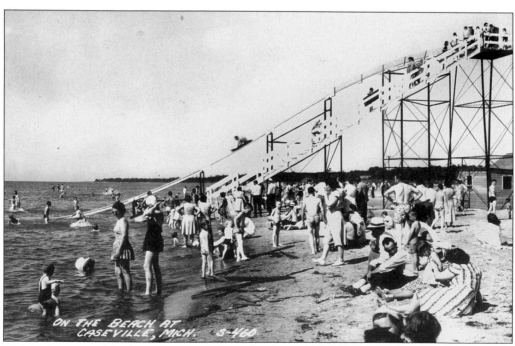

This is the water slide that once stood along the shore in the County Park.

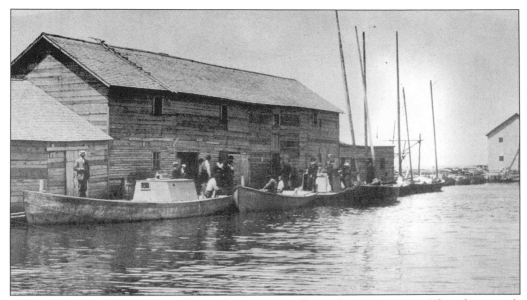

Fishing excursions out of Caseville Harbor were popular in the summertime. This photograph was taken around 1905.

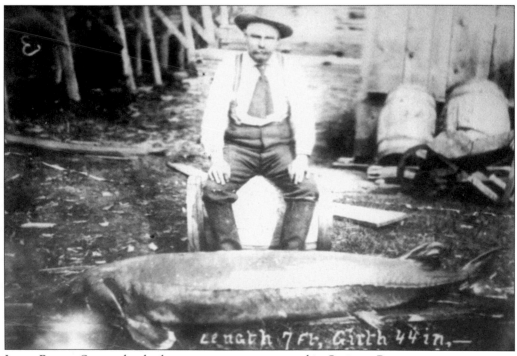

Length 7 Ft, Girth 44 in,

James Reeves Sr. caught the largest sturgeon ever netted in Saginaw Bay.

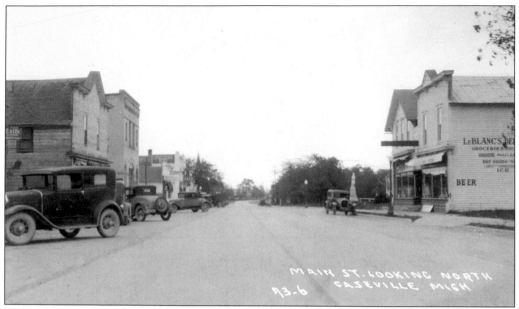

This is Main Street looking north in Caseville

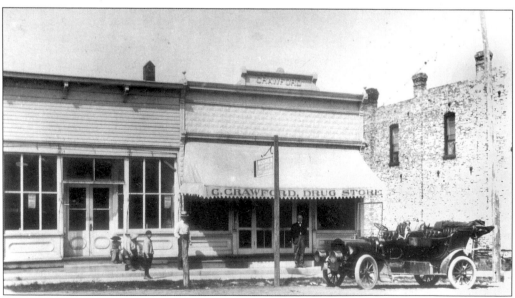

The C. Crawford Drug Store was located on Main Street in Caseville.

Four
ELKTON

Elkton was first called "Oliver Center," being named after an early settler and first Supervisor of Oliver Township, John Oliver. Elkton was incorporated as a village in 1897. Several stories have circulated speculating on how Elkton received its name. Benjamin Tripp, an early pioneer of Port Austin, claimed that while he operated a meat market in Port Austin, three elk were shot at the Bagley camp and brought to his market. He said that the three elk weighed about a ton and from that time on, Bagley camp was known as the Elkton Camp. Later the spot was known as the Elkton Village. The first village council meeting in Elkton was held December 9, 1897. The officers elected were: President D.J. McCall and Clerk H.C. Wales; Trustees M.A. Vogell, Henry Kellerman, H. Snider, Herman Magidsohn, George Weber, and Charles Soehner. The first school was built in 1887 and used until 1902. It was then used as the Village Hall and Jail (with two cells) until 1939. Elkton's first newspaper was published in 1898 and was called the *Huron County Review*, with Donald Wales as editor. The first bank was erected in 1893 and was owned by A.H. Ole and Son. It was one of the structures that burned in the Great Elkton Fire of February 1906. With Simon Hoffman as the first postmaster, the post office was established November 24, 1886. At that time, the population of the village was listed at 30 and mail service was provided to 500 people in the surrounding area. The present population of the village is approximately 900 with mail service to 2,900 customers.

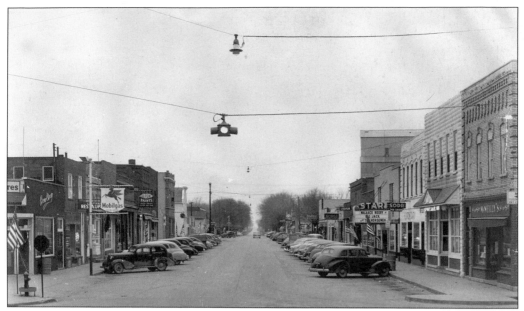

This is Main Street in Elkton looking north in 1947.

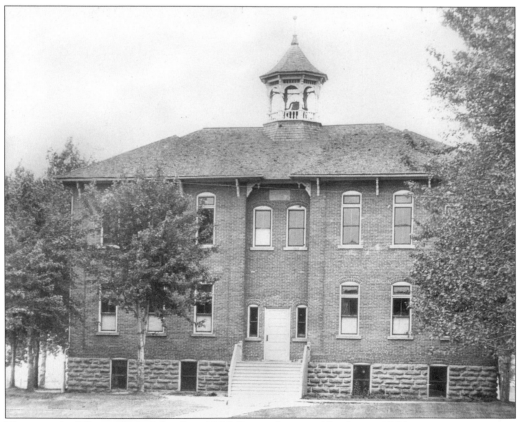

This was the Elkton High School in 1908. It was destroyed by fire in 1931.

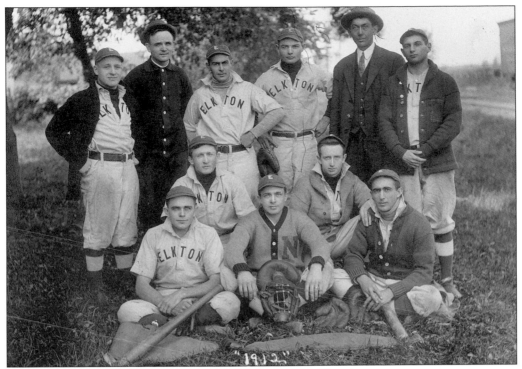

The 1912 Elkton baseball team was the champion of the Thumb.

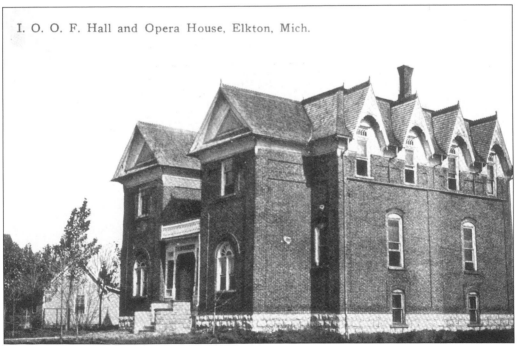

I. O. O. F. Hall and Opera House, Elkton, Mich.

This is the I.O.O.F Hall and Opera House in Elkton.

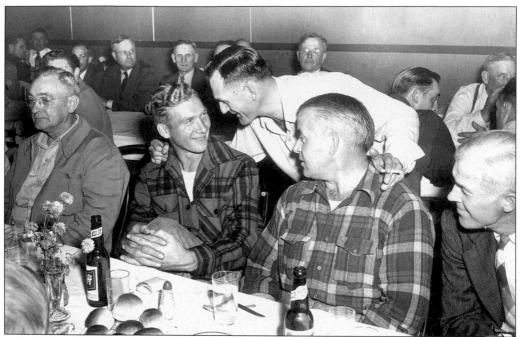

Hal Newhauser (second from the left), pitcher for the Detroit Tigers baseball team, met with the Sportsman's Club in Elkton.

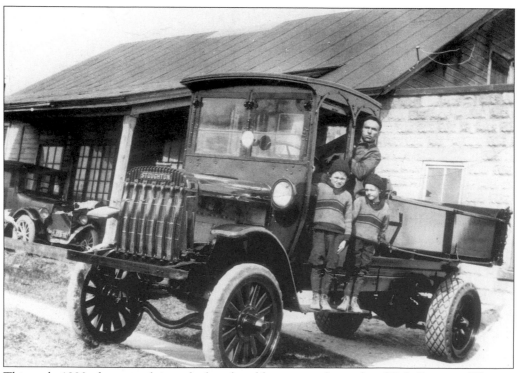

This early 1920s dump truck is parked at the old creamery, located on High Street in Elkton.

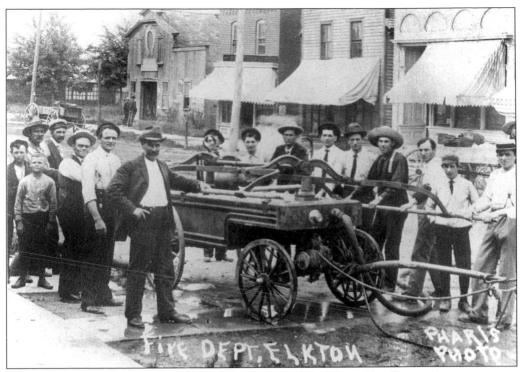

This hand-drawn pumper was used in the early days of the Elkton Fire Department.

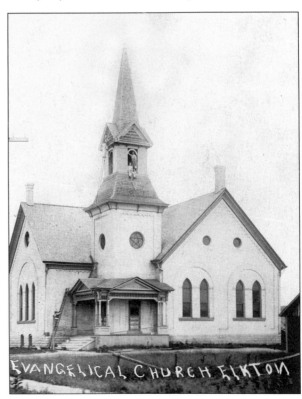

This is an early photo of the Evangelical Church in Elkton.

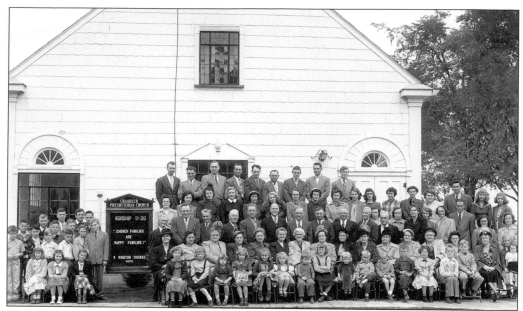

This is a photograph of the Chandler Presbyterian Church congregation, taken in 1950.

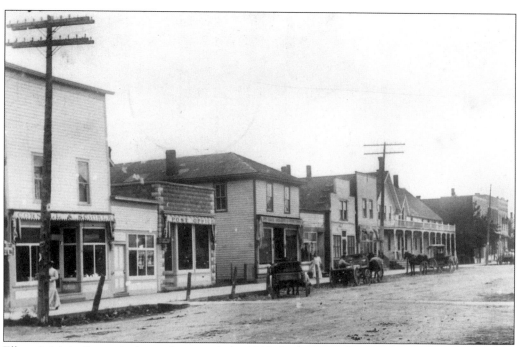

Elkton's Main Street is shown here in about 1910, looking south.

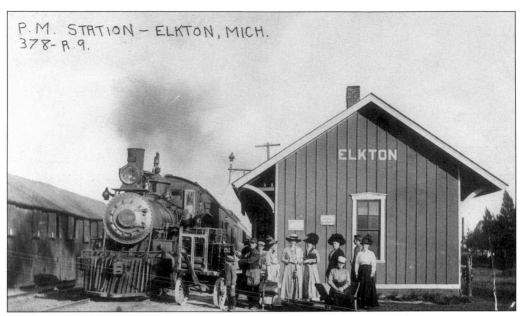

The old railroad station was the center of activity in town at the turn of the century.

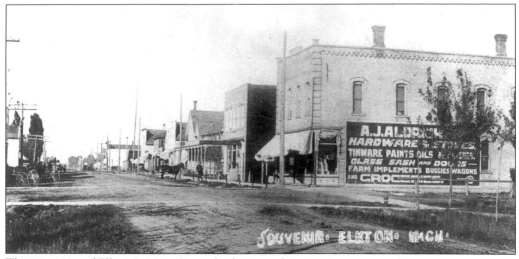

This is a view of Elkton's Main Street looking north in 1910.

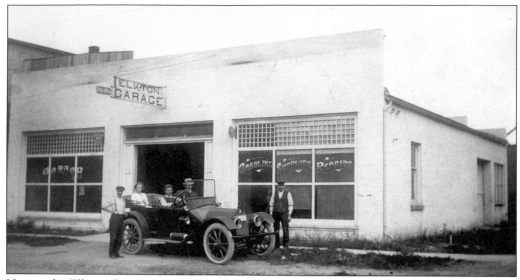

Here is the Elkton Garage as it appeared in the early 1900s.

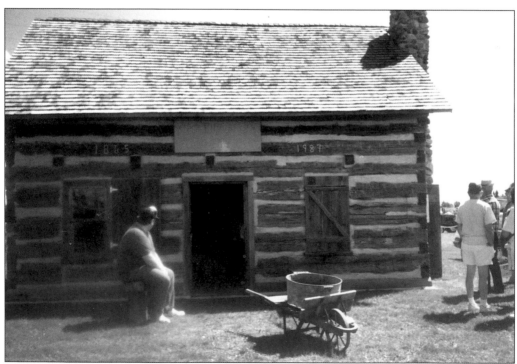

This restored log cabin is located in Ackerman Memorial Park. It was originally built in 1865 and housed a pioneer family. The cabin is maintained by the Elkton Historical Society.

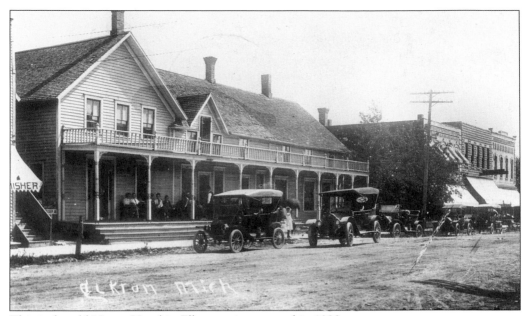

This is the old Huron Hotel in Elkton as it appeared in 1920.

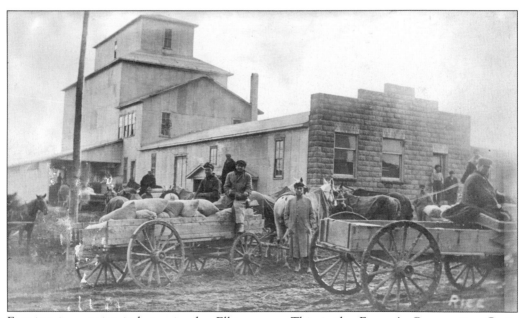

Farming is a major industry in the Elkton area. This is the Farmer's Cooperative Grain Company, located on Market Center in Elkton.

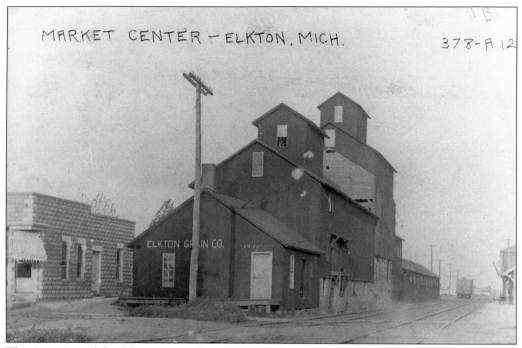

This is a view of the Elkton Grain Company on Main Street in the early 1920s.

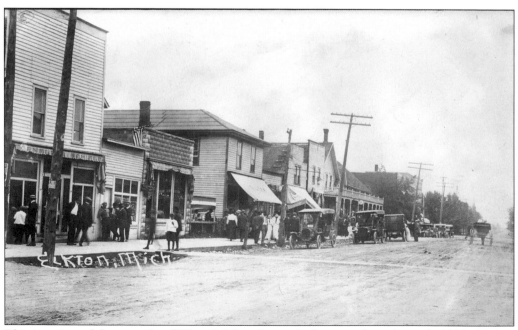

This is a view of the eastside of Elkton's Main Street, looking south in the early 1920s.

Five
HARBOR BEACH AND
PORT HOPE

The story of Harbor Beach begins in 1837 at Rock Falls where John Allen and Alanson Daggett settled to fish and start a lumbering operation. Jeremiah Jenks soon arrived and lumbering began in earnest. Rock Falls settlers John Hopson and the Ludington family moved a mile or so north to an area with a sandy beach and called their settlement Sand Beach. When all the timber was cut at Rock Falls, Sand Beach became the primary settlement and became a town in 1855. When Huron County was organized in 1859, Sand Beach became the first county seat. The United States Government constructed a large harbor of refuge at Sand Beach to offer shelter for sailing ships and steamers during stormy weather. In 1899, the town's name was changed to Harbor Beach. Such a large harbor resulted in more growth, and by 1902 the Huron Milling Company was formed. Today, Harbor Beach is Huron County's second largest city and only deepwater port.

A short distance north along the shore is the village of Port Hope. In the 1850s, W.R. Stafford operated a sawmill and salt wells there. The village name comes from William Southard, an eastern investor with Stafford, who first arrived by steamer and was put in a small boat to row ashore in stormy weather. After rowing most of the night, Southard vowed that if he made it safely to the shore, he would name the place his "Port of Hope." As the land was cleared of timber, farming became the most important occupation in the area and remains so today. (Photographs of Port Hope and related captions courtesy of James Hunter.)

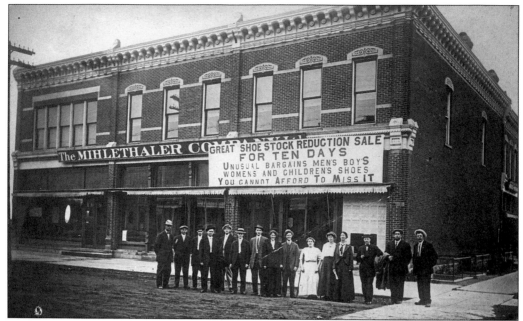

Built in 1882 where the present Community House is located in Harbor Beach, the J. Jenks & Company General Store was changed to the Mihlethaler Company Store in 1902 and did business at that location until 1918–1919, when it was relocated. Those pictured are, from left to right: William Dergis, Tom Cade, unknown, Hugh Crull, Frank Kuchenbecker, Irving Toppin, Harry Bowman, Mattie Lytle, Tony Duda, Mable Lowery, Wilhemina Wick, Darrah Harwood, Frank Hyatt, unknown, and Emil Bernhardt.

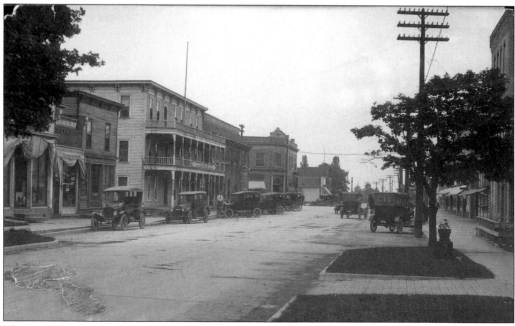

This is Huron Avenue in Harbor Beach looking north in about 1930. Visible are the Herman Jacobs Store (on the left), the McIlhargie Building, the Wilson House, and the Corner Drug Store.

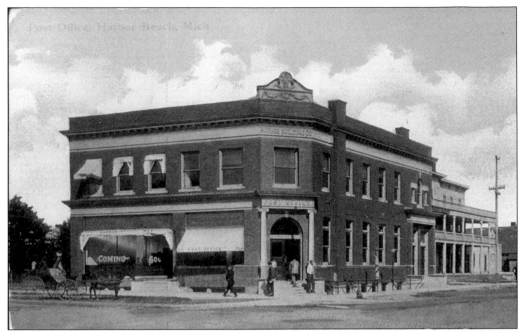

The Post Office (built in 1908) on the northwest corner of State Street and Huron Avenue in Harbor Beach, is shown here as it appeared in 1910. Today it is the Biroscak Hardware store.

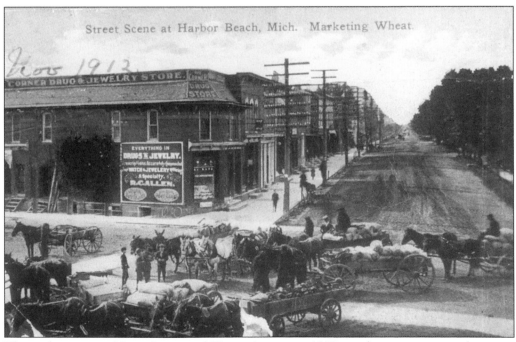

This is the corner of State Street and Huron Avenue in 1912, as wheat comes to market.

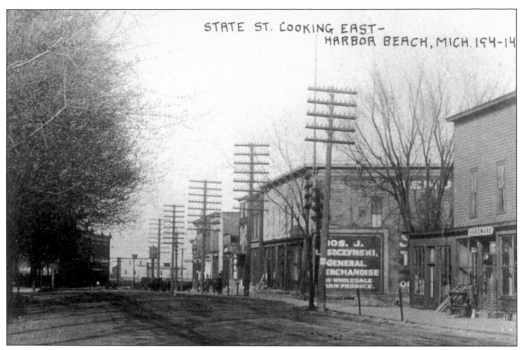

This is the Joseph Leszczynski General Store on State Street in Harbor Beach, looking east at the corner of First Street in about 1890.

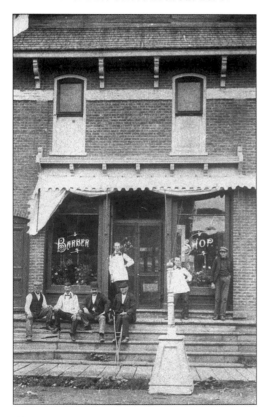

The Lee and Lytle barbershop in the Corner Drug Store building is shown here about 1892. Dr. P.O. Wagener, a physician in Harbor Beach from 1881 to 1921, is the third from the left.

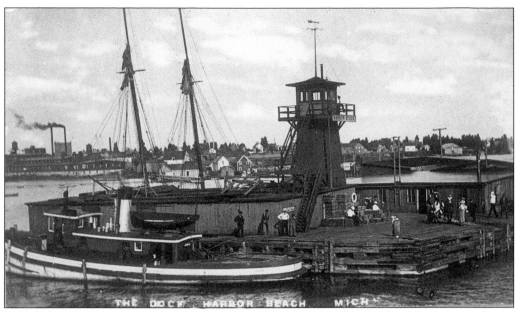

The dock and the Coast Guard lookout tower located inside the harbor of refuge are shown here in the early 1900s.

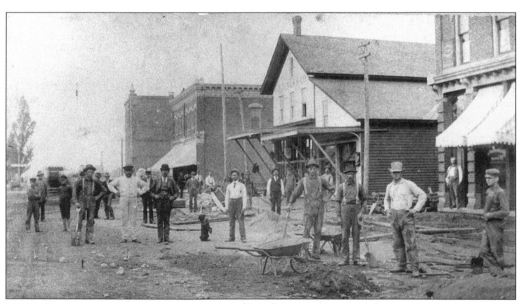

In 1906, repairs to Huron Avenue were well underway when this photo was taken. City Hall and the Mihlethaler Store are in the background.

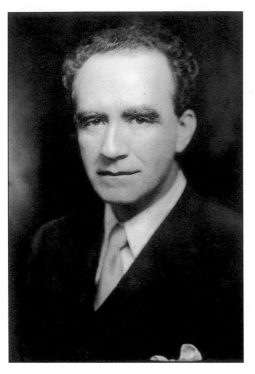

Frank Murphy was born in Harbor Beach on April 13, 1890. He graduated from the University of Michigan Law School in 1914. He served as recorder's court judge in Detroit from 1920 through 1923; as mayor of Detroit from 1930 to 1933; governor general of the Philippines from 1933 to 1936; as governor of Michigan in 1937 and 1938; as U.S. Attorney General in 1939 and 1940; and as a U.S. Supreme Court Justice from 1940 until his death in 1949.

Judge James H. Lincoln was born on August 26, 1916, and was raised on a farm three miles south of Harbor Beach. He graduated from the University of Michigan in 1938. Judge Lincoln was nominated for mayor of Detroit and served as a Detroit City Councilman from 1954 to 1960. He was Wayne County Juvenile Court Division Probate Judge from 1960 to 1977 and was a member of the Michigan Correctional Commission from 1984 to 1991. Judge Lincoln is presently retired in the Harbor Beach area.

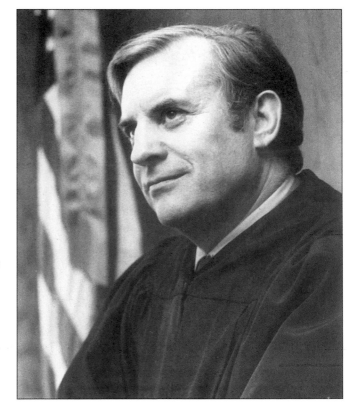

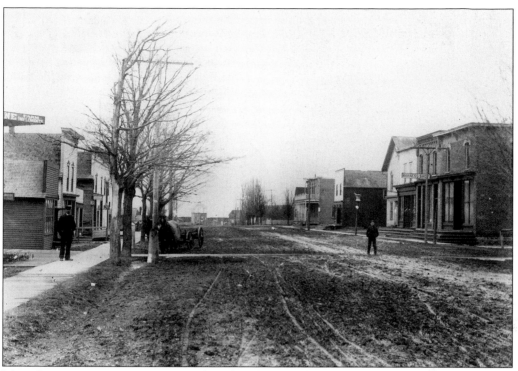

Main Street in Port Hope is unpaved in this photograph taken in the spring of 1908. Wagon wheel marks are clearly visible in the wet roadway.

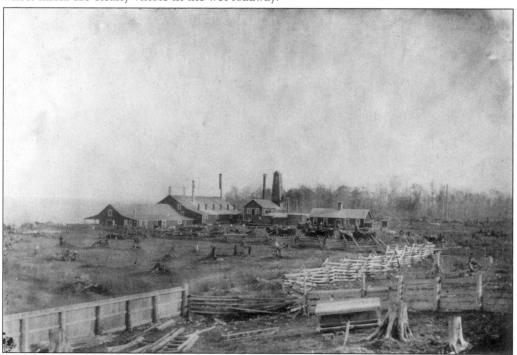

This early photograph shows the W.R. Stafford Salt Block in Port Hope. Brine water was pumped from wells and boiled to obtain the salt.

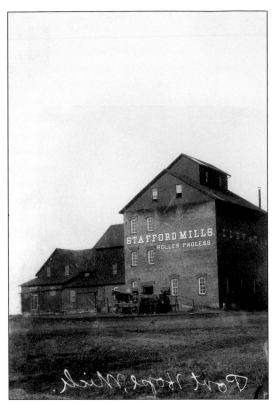

The Stafford Mill was constructed in 1886 on the lakeshore in Port Hope and used a roller process to grind winter wheat into flour. The mill became part of the Bad Axe Grain Company in the early 1900s. In the 1970s it was acquired by Thumb Farm Service and is still in use today making it one of the oldest grain processing plants in Michigan.

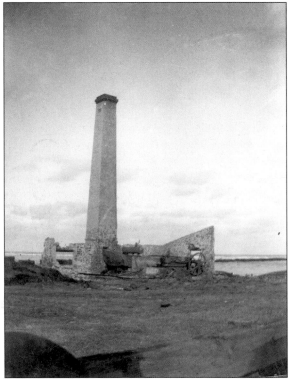

This is all that remained of the W.R. Stafford Sawmill after the Great Fire in 1881. The chimney remains today as the only landmark to the once thriving business.

The Port Hope High School is shown here as it appeared in 1888.

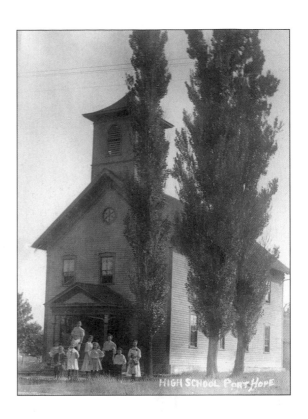

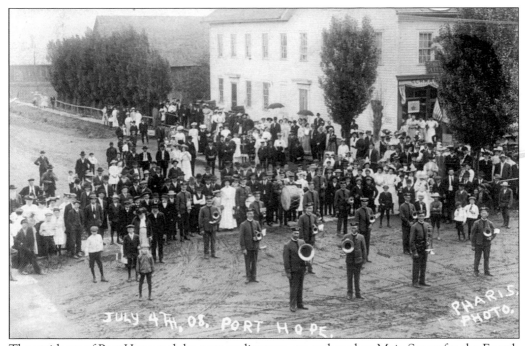

The residents of Port Hope and the surrounding area are gathered on Main Street for the Fourth of July parade in 1908.

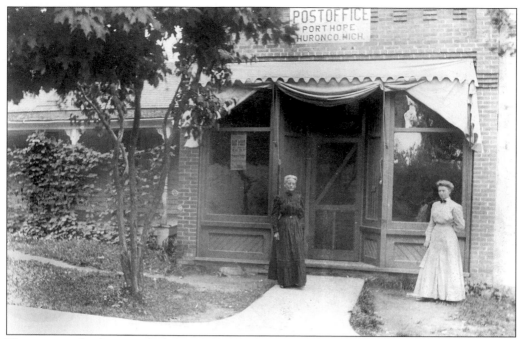

This is an early photograph showing the Port Hope Post Office.

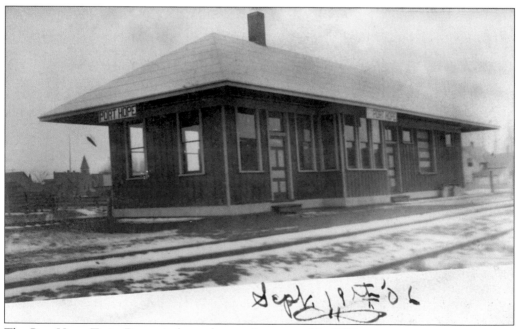

The Port Hope Train Depot is shown here as it appeared in 1906.

Six
PIGEON

Although there were settlements along the shores of Saginaw Bay and Lake Huron as early as 1836, the interior of the county was not settled until many years later. Exploration of the interior and the vast pine forests was by foot or by plying the rivers with canoes. When the Pontiac, Oxford, and Port Austin Railroad (later the Pontiac, Oxford and Northern) finished its line to Caseville in 1882, it passed through the small settlement of Berne. In 1886, the Saginaw, Tuscola, and Huron Railroad extended its tracks easterly from Bay Port and crossed the Pontiac, Oxford, and Port Austin tracks one mile south of Berne. That crossing became known as Berne Junction. In 1891 the name was changed to Pigeon because the Pigeon River flows just to the west of the town. The river took its name from the large flocks of pigeons that fed and nested along its banks. A few years later, the townspeople considered changing the name to "Winsor City." Although many prominent businessmen were in favor of the change, the village name remained the same and was incorporated as "Pigeon" in 1903. The town grew rapidly and by the early 1900s, there were two grain elevators, a grist mill, a foundry, two large hotels, an opera house, two harness shops, a meat market, a photography gallery, two furniture and undertaking establishments, five blacksmith shops, a laundry, a livery, a barbershop, two doctors, seven churches, and a ten-grade school. By 1904, there were 582 residents in the village. Many were immigrants from central Europe or the British Isles. Most found their way to Pigeon after spending their first years in the New World in New York, Pennsylvania, Ohio, and Canada. Pigeon continues to grow as a farming center although at a slower pace than in the early days. The townspeople are already planning for—and looking forward to—a 100th anniversary in 2003.

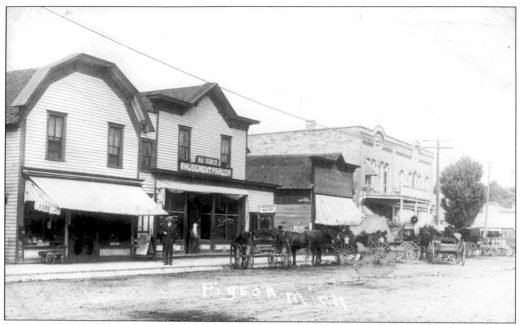

This postcard was mailed from Pigeon to Shakespeare, Ontario, in 1914. The buildings were located on the westside of Main Street at the north end. The first building on the left is Karr's Grocery, then B.D. Eddy Amusement Parlor, John Madiger's Shoe Store, the A.W. Brueck Company and the two-story Winter's Block.

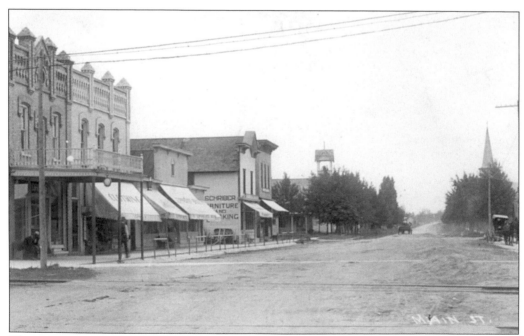

This street scene is looking south from the Pere Marquette Railroad tracks. The first building on the left is Campbell's Drug Store, followed by a clothing and shoe store, the Leipprandt Brother's store and the W. A. Schriber Furniture and Undertaking establishment. The First Presbyterian Church tower and the steeple of Cross Lutheran Church are visible on the right.

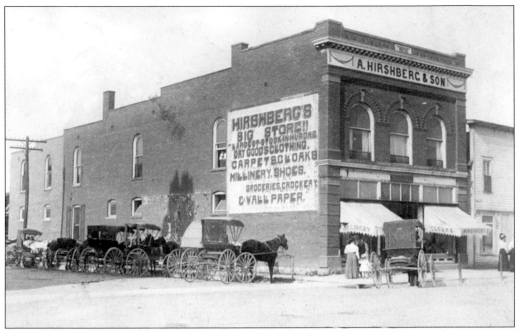

The contract for construction of Hirshberg's Big Store was let to Zimmer and Bowman of Sebewaing in July, 1899. A estimated crowd of 2000 people visited the store on opening day in April of the next year. Harry Hirshberg, the junior member of the firm, served on the first (1903) village council. He continued in business until 1928, when the store was closed.

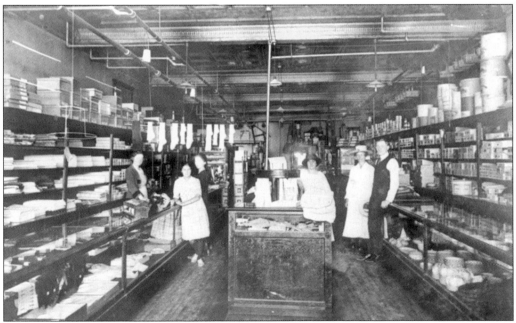

This is an interior view of Hirshberg's Big Store. It was located at the northwest corner of Main Street and Michigan Avenue. The firm was a dealer in general merchandise including a full line of shoes, cloaks, carpets, groceries, hardware, dry goods, furs, clothing, millinery, bazaar goods, stoves, furniture, pianos, and much more. The Hirshberg slogan was "Everything for the Family".

The Evangelical Church
was founded in 1885 and
dedicated in 1909.

The Cross Lutheran Church
was founded in 1891 and
dedicated in 1905.

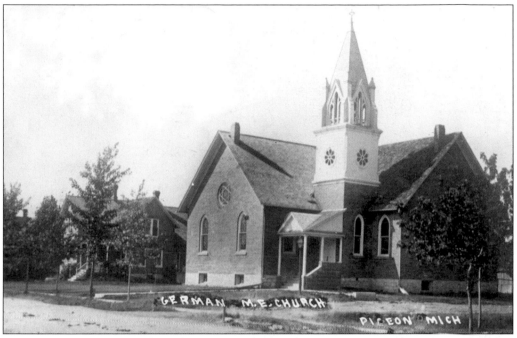

The German Methodist-Episcopal Church was founded in 1871 and dedicated in 1899.

The Grace Evangelical
Lutheran Church was
founded in 1902 and
dedicated in 1904.

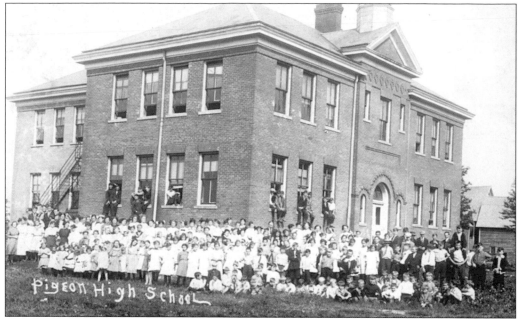

The first meeting of the Winsor School District Number 4 was held in February of 1872. During 1873 and 1874 three-month school terms were conducted in a log house in Section 3 of Winsor Township. In 1885 classes were held in the German Methodist-Episcopal Church on the banks of the Pigeon River about one-half mile west of Pigeon. The wood frame building was later moved to town and, in 1896, the school shown here was built. This school burned in 1916 and classes were held in various church and public buildings until the new school was ready for classes in the fall of 1918. Beginning with a graduating class of four in 1899, 1,346 students were graduated through the years until 1960 when a larger new school was built.

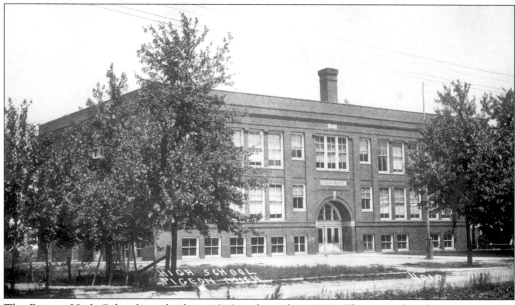

The Pigeon High School was built in 1918 and razed in 1980. The central arch remains at the site of the school on Paul Street as a memorial.

The 1923 Pigeon High School basketball team won the State class D trophy in the tournament held at Mount Pleasant, Michigan. The Pigeon team defeated five other teams over a day and one-half tournament. The players were, from left to right: (front row) Raymond Clabuesch, Leonard McIlmurray, and John "Jake" Wagester; (middle row) Harry Klinger, and Arnold Schumacher; (back row) Etril Leinbach, Clare Harder, and Newton Miller.

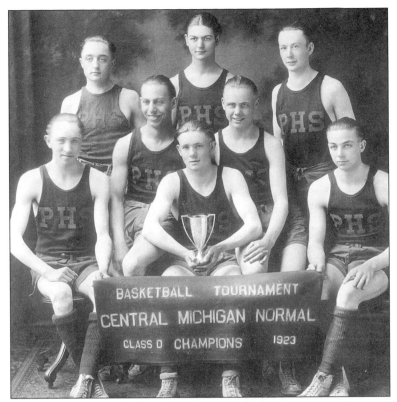

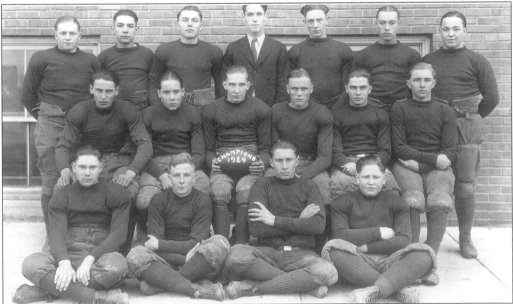

This is the 1924 Pigeon High School Thumb Championship Football team. They are, from left to right: (front row) Wally Leipprandt, Philip Morse, Roy Hartman, and Bob Spense; (middle row) John "Jack" Paul, Jerry Dondineau, Jim Brown, Arnold Schumacher, Waldo Damm, and Leonard Wurtz; (back row) Crawford "Ham" Spense, Alfred Roberts, Ervin Doepker, Vaughn Garrison (Coach), Walter Clabuesch, Earl Hartman, and George Nienstedt.

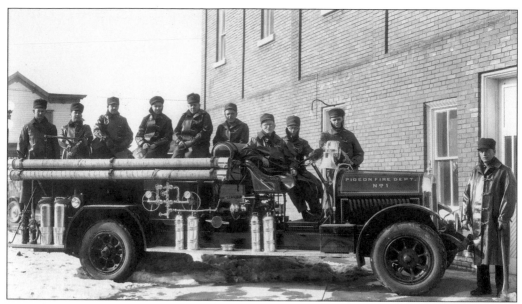

As early as 1897, a bucket brigade was organized to fight fires with Richard Schroeder as chief. Several years later a two-wheeled hose cart was purchased. This was rolled to the fire scene with several men pulling on the long tongue and others pushing the cart. The first fire truck was acquired in 1927. This was an American LaFrance Fire Engine Company combined-pumper and chemical fire truck that cost $6,750. The money was contributed by area farmers. The Village did not contribute but agreed to house and maintain the truck and to compensate the firemen.

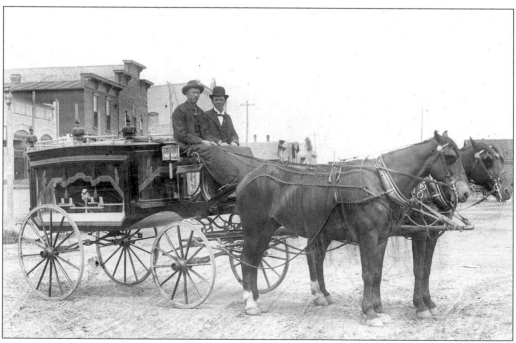

This horse-drawn hearse was used in Pigeon in the early 1900s. Seated beside local undertaker William Schriber is John Walker, who is holding the reins. The photograph was taken on Main Street.

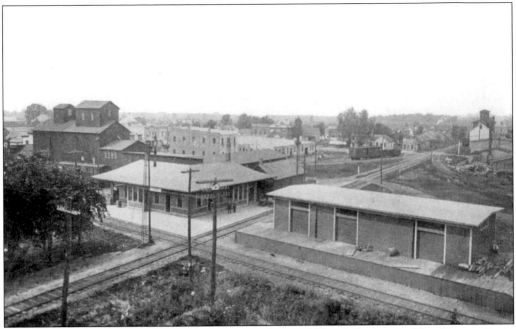

This is the crossroad of the Pere Marquette and Grand Trunk Railroads. The Pigeon Grain Elevator is shown at the far left, the village and township hall above the depot, the Farmer's Elevator at the far right, and the unloading dock and storage shed for the railroads is at the lower right.

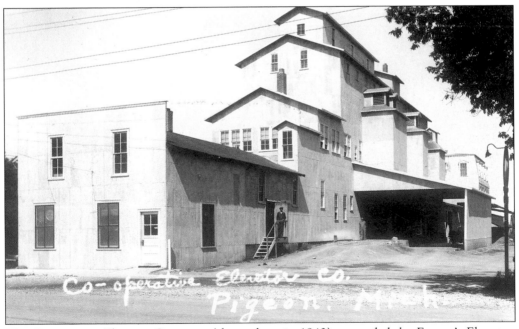

The Cooperative Elevator Company (shown here in 1940) succeeded the Farmer's Elevator, which was organized in 1915 after purchase of the old Leipprandt Brothers Elevator. In the 1950s this building was torn down to make room for modern, skyscraper-high cement silos for grain storage.

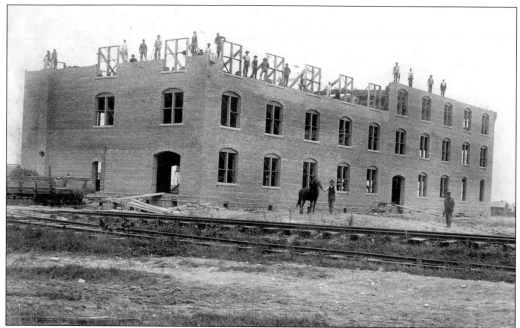

This is the Gould Carriage Company under construction in 1904. Harry Gould erected the building with proceeds from the sale of 125 residential lots platted as the Gould Addition to the village of Pigeon. With the advent of the automobile, carriage and buggy building was no longer profitable, and the business closed. The Pigeon Novelty Company occupied the building for a short time during which the third floor was used for basketball games.

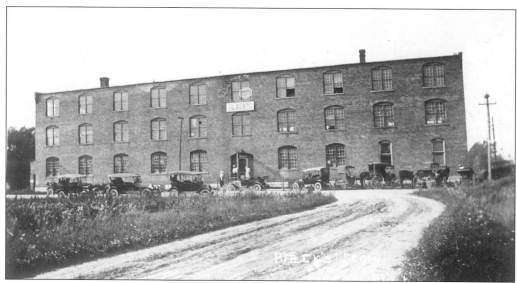

G.V. Black purchased the three-story buggy factory in 1914 and conducted a very successful general merchandise business until February 1925 when the store was completely destroyed by fire. The Black Store published its own newspaper, *The Live Wire*, with a circulation of 10,000. Customers came by train from as far away as Pontiac and Saginaw and had their fare refunded after purchases of a certain amount. "Black's Bargains" advertising signs covered the entire sides of several barns in the area.

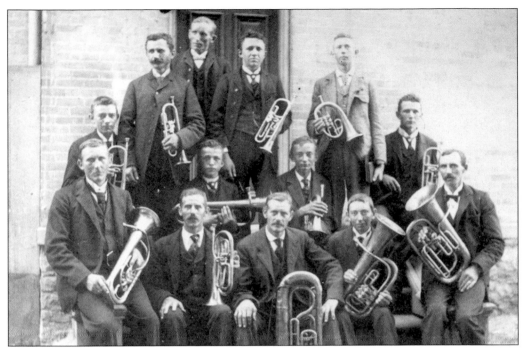

Soon after Cross Lutheran Church was organized in 1891, a group of members formed a band. The band accompanied congregational singing at regular services and other special occasions. The band would accompany the first verse of a hymn and the congregation would sing the next verse a cappella, alternating for sometimes 15 or more verses. The last performance of the band was in August of 1991, at the congregation's 100th anniversary.

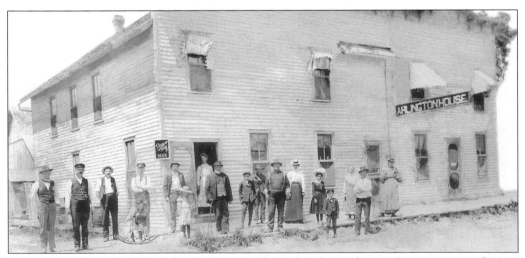

The Arlington Hotel was built by Herman Kleinschmidt on the southwest corner of Main Street and Michigan Avenue in 1887. Two years later, the building was sold to George B. Winter, who in turn sold it to R.W. McElmurray and Lee Elenbaum in 1898. That year, acetylene gas lighting was installed and a year later a large addition was built and steam heat was added. The building was moved in two parts in 1912 and converted into separate residences. In 1920, the Arlington Block was purchased by George H. Anklam and used in connection with his automobile business.

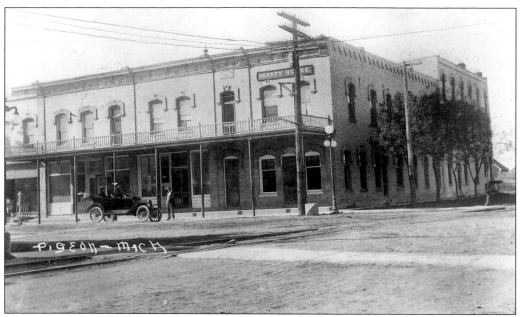

All the buildings in Pigeon were of wood frame construction until 1895, when William Heasty constructed the Heasty Hotel of white brick. It was the county's finest hotel at that time. It followed the Arlington Hotel (1887) and the Junction House (1886) as Pigeon hotels. Although the original building still stands, it is no longer used as a hotel.

SPECIAL DINNER
HOTEL HEASTY
Seventy-five Cents

NEW YEAR'S DINNER
1916

CREAM OF TOMATO

OLIVES ——— PICKLES

ROAST TURKEY---CHESTNUT DRESSING
ROAST BEEF AU JUS

MASHED POTATOES SUGAR CORN
GREEN PEAS SWEET POTATOES

PINEAPPLE SALAD

MINCE PIE APPLE PIE
ENGLISH PLUM PUDDING---BRANDY SAUCE
ICE CREAM
CAKE

COFFEE TEA MILK

This is the Heasty Hotel Menu.
Note the 75¢-dinner price.

Seven
PORT AUSTIN, PORT CRESCENT, KINDE, PINNEBOG, AND GRINDSTONE CITY

Huron County's north shore area is notable for its unusual rock formations that intermingle with sandy beaches. The settlements were among the earliest along Lake Huron. Indians found the rocks west of Port Austin a useful place to grind corn, and maple trees nearby were fine for making syrup. By the 1850s, many pioneers arrived to work in the lumber camps and sawmills. Early settlers were Jeduthan Bird (1837) at Port Austin; Captain Peer (1834) at Grindstone City; Walter Hume (1844–45) at Port Crescent and on to Pinnebog; and Otto Storbeck (1870s) at Kinde.

The earliest lumber barons bought huge tracts of land from the federal government for paltry sums per acre, and harvested the white pine and other hardwoods, most of which they shipped to Ohio ports. In Port Austin, particularly, they built large homes, which lined the main streets. Many of them are still standing. Some early lumberjacks cleared land for farms after getting patents from the government in the latter 1850s. The salt industry and fishing flourished.

Port Austin, luckily, did not burn in the disastrous fire of 1881. Many early records were preserved there, from newspapers to church missions into the interior. Grindstone City, uniquely named for the quality of the sandstone rock found there, became a beehive of activity. Its grindstones were shipped all over the world. Port Crescent developed another industry after lumbering dwindled. Sand from the huge dunes was loaded and shipped to the Ford Motor Company for use in its foundry at River Rouge. In the 1880s Kinde and Pinnebog grew into trading centers for farmers, who settled after buying land from those who had cut down the timber. In the 20th century, Port Crescent died out completely and is now a state park and camper's paradise. Grindstone City has become a picturesque mecca for fisherman. Kinde caters to the needs of the area farmers, and the north shore area's school is centrally located there. Pinnebog, with its Indian name, is still on the map.

While serving as the location for an Air Force early warning radar station from 1950 until the 1990s, Port Austin has grown into a summer resort with a number of condominiums and fine restaurants. The Port Austin Level Company and Salvo are among the small manufacturing firms in town. The agricultural countryside is within calling distance of the water.

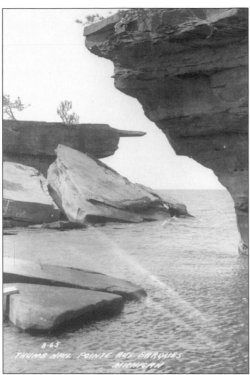

One of the unusual rock formations on the shore at Pointe Aux Barques is often called the "Thumb Nail." It is part of a group of rocks that were named by early explorers according to their shapes. Pointe Aux Barques is now a private resort.

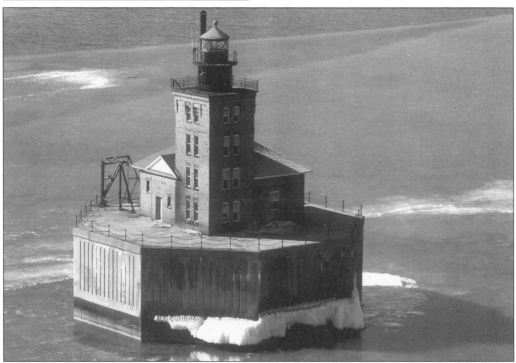

The Port Austin Reef Lighthouse lies about two and one-half miles northeast of Port Austin at the end of a long reef. It was completed in 1873 and refurbished in 1899. When the lake levels are low, some parts of the reef can be seen above the water.

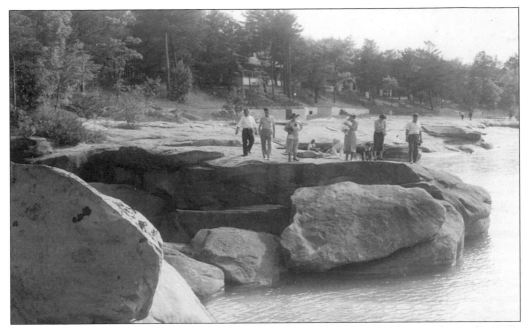

West of Port Austin, there is a second area that became a private resort in the early 1900s known as "The Broken Rocks." Its rocky shores and sandy coves were once used as a summer campground by the Chippewa. Local boaters know they must watch out for submerged rocks when traveling close to these shores.

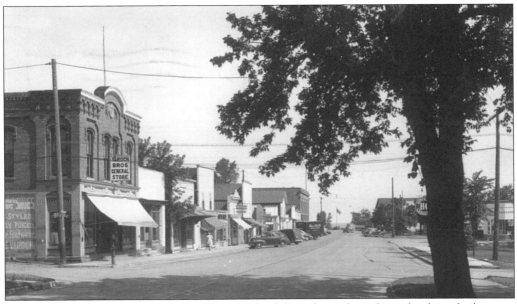

Main Street in Port Austin leads north to the lake, where three huge loading docks were crowded with schooners and steamboats back in the lumber days, from the 1850s through the 1880s. These docks were washed away in the Great Storm of 1913.

81

The corner of Main (Lake) and Spring Streets has been busy for 150 years. The stagecoach stopped down Spring Street on the right from 1862 until the railroad came through in 1882. An early newspaper was published here beginning in 1859. The county seat was moved here from Sand Beach in the 1860s and then to Bad Axe in the 1870s.

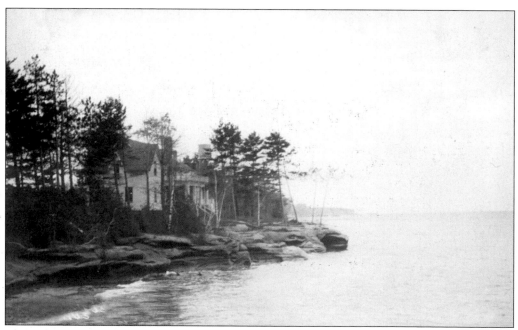

The Difuniac home, located west of Port Austin, was built by descendants of J.W. Kimball, who arrived in 1852 and engineered the first steam-powered sawmill for Smith, Dwight & Company. They cut 120,000,000 feet of lumber for eastern markets in the years that followed.

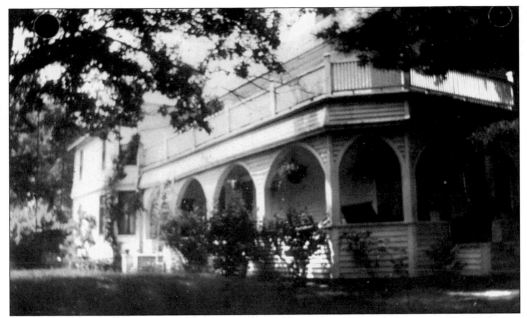

Pine Rest, one of four large homes owned by the Wallace brothers, stood on West Spring Street, where the Kooky Golf is located today. The four Wallace brothers ran extensive businesses throughout the county by 1900, including quarries and grindstone manufacture, general merchandising, commercial fisheries, grain elevators, and general banking businesses.

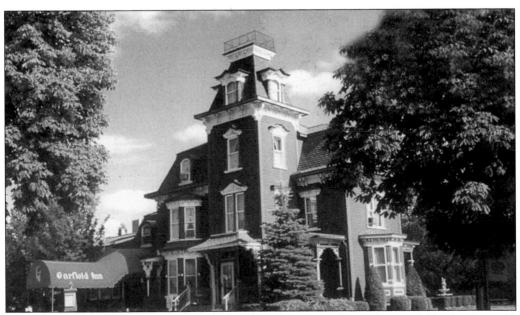

The Garfield Inn, now a well-known bed and breakfast, was the residence of Charles Learned, who began an extensive lumber operation in 1859 with partners F. Ayres and E. Wiswall. President Garfield, a personal friend of the Learneds, visited there.

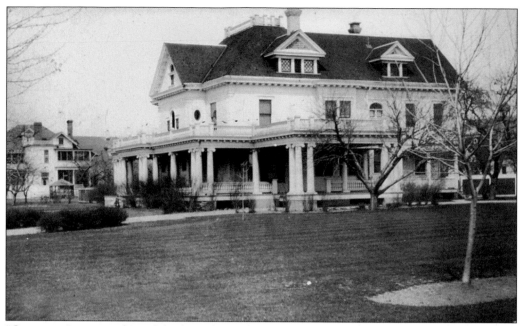

"Questover" was another of the huge homes built with lumber money that lined the streets of Port Austin in the second half of the 1800s. Among the early owners were Mark Carrington, John Wallace, and Frank Kinch.

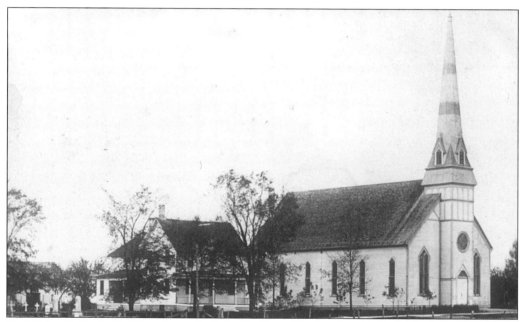

St. Michael's Catholic Church was built by Fr. Peter Kluck, who traveled through the woods to serve Christians in the early 1860s. All denominations helped build it, finishing a smaller structure by 1867. The buildings shown here date back to 1883.

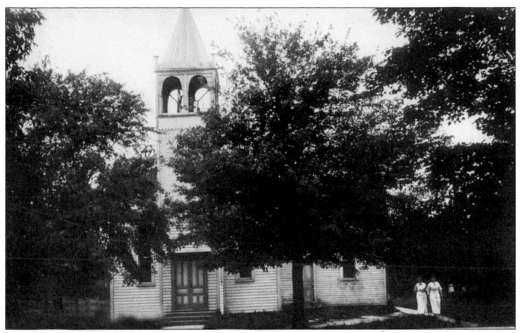

The first Methodist Church shown here later became parsonage for the United Protestant Church, which combined the congregations from earlier Baptist, Presbyterian, and Methodist Churches. This old building was torn down and replaced with a modern home for the minister.

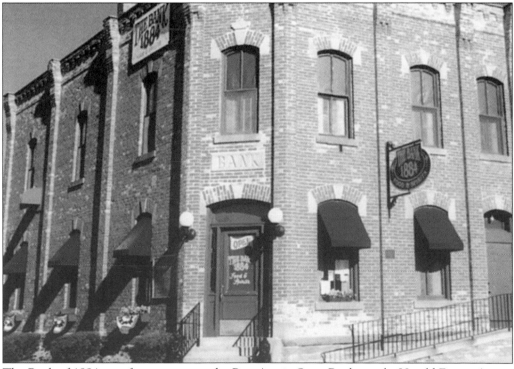

The Bank of 1884 was, for many years, the Port Austin State Bank, run by Harold Finan. A new bank building was constructed in recent years and the old site became a gourmet restaurant.

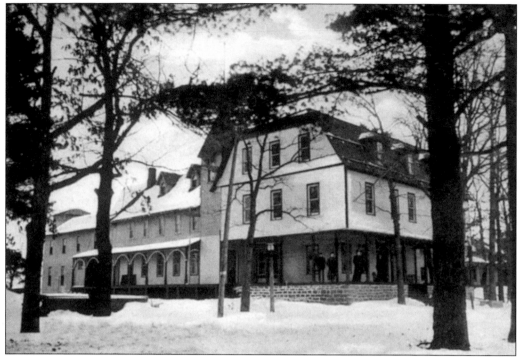

After the arrival of the railroad, vacationers became more numerous. This building was known as the Point of Pines Resort and was located on Spring Street at the foot of Prospect Street. It later became the Edgewater Hotel and was eventually torn down to make room for more modern lakeshore properties.

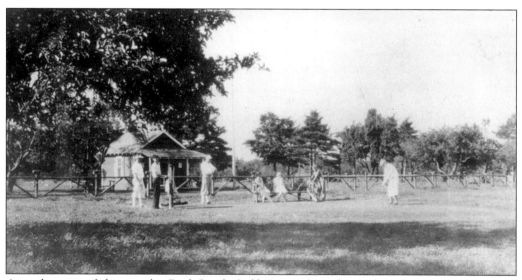

A predecessor of the popular Bird Creek Golf Course (now located south of town), the Port Austin Golf and Country Club was organized in the late 1920s by prominent businessmen and located in the area now known as Port Austin Heights. The depression of the 1930s forced it to cease operations.

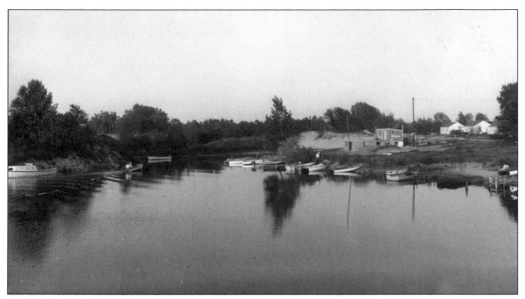

After the lumber port years, and before the advent of the federal harbor of refuge project in the 1950s, the mouth of Bird Creek became a quiet fisherman's docking place for wood rowboats with outboard motors. This area is now filled with condominiums, marinas, and a large state launch site for fishing boats.

Construction of tourist cabins alongside the old Lakeside Motor Sales in 1932 heralded a new era for Port Austin. At the same time, rentals mushroomed for summer visitors and many people became cottage owners. Today, the town has many year-round retiree residents.

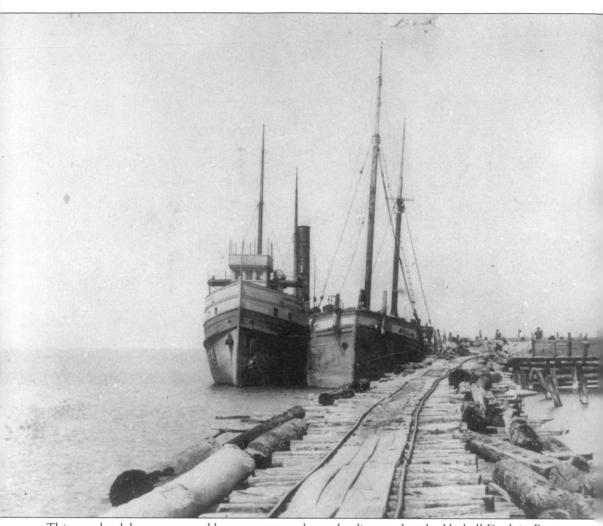

This wooden lake steamer and her consort are shown loading sand at the Haskell Dock in Port Crescent in the early 1900s. Today, the dock is gone and the area is now the Port Crescent State Park.

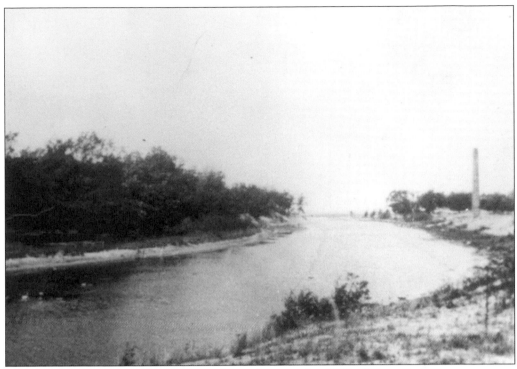

The mouth of the Pinnebog River is shown here in the 1950s. When Port Crescent was a bustling lumber town, both sides of the river were filled with homes and businesses. There was also a long loading dock stretched out into the lake at the mouth of the river.

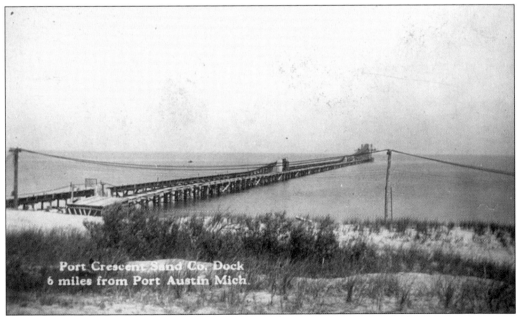

A new dock for loading sand was built to the south along the shore in 1924 by the Port Crescent Sand and Fuel Company, after they took over from Garey and Conley, successors to Haskell. This operation ended in 1932, and the dock was left to the ravages of time.

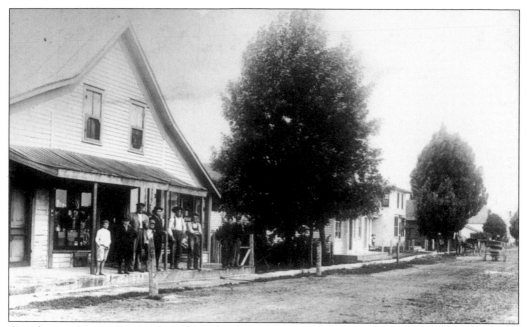

Grindstone City's Copeland Road still has some of the old buildings shown here. Now it is a tranquil place to visit, relax, and buy an ice cream cone at the old store.

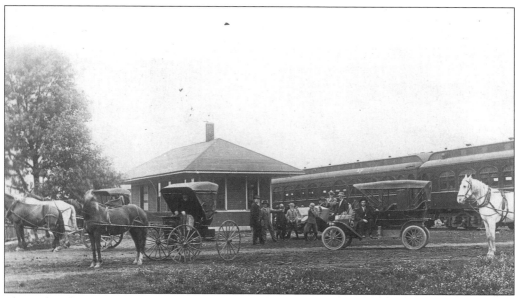

The railroad track, which extended north from Bad Axe through Kinde and Port Austin, turned east along the shore to Point Aux Barques and then still further to Grindstone City. Both passenger and freight service were offered.

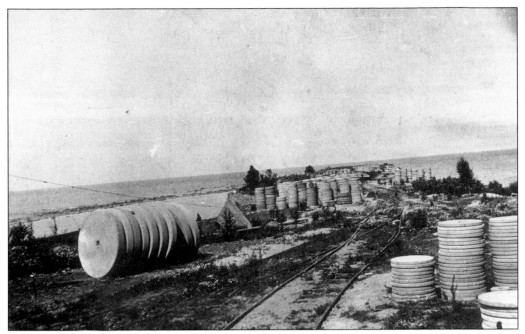

The dock at Grindstone City, destroyed in the Great Storm of 1913, was used to ship grindstones by water until the railroad arrived in the late 1800s. Thereafter, they were shipped by rail.

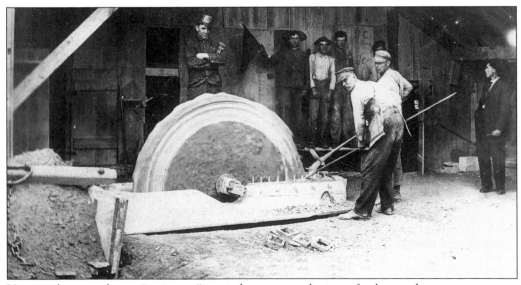

Here workers are shown "truing up" a grindstone, to make it perfectly round.

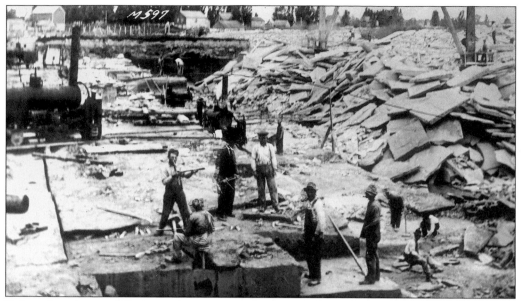

Before the advent of Carborundum as a grinding material, grindstones were shipped to many parts of the world. The steam engine used in their manufacture is shown on the left in this picture of the heavy rock quarry. It was sold for scrap shortly before World War II.

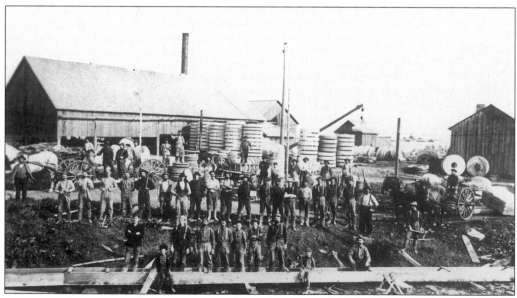

This view of workers and piled stones at the waterfront in Grindstone City dates back to the early 1900s. Lake Huron and the end of the long point of land stretching out into the lake are visible in the far background at the right.

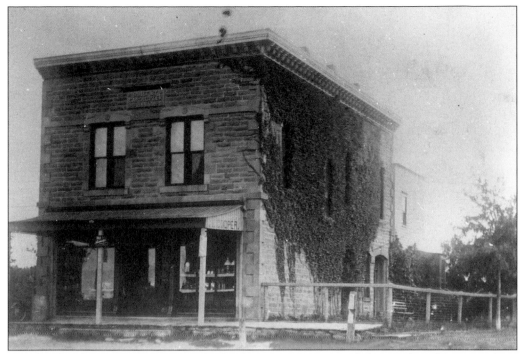

This landmark at Grindstone City, built of quarry stone, is a solid reminder of Captain A.G. Peer, who discovered the unusual quality of the sandstone in the area after he arrived in 1834. He bought 400 acres and started the grindstone industry here.

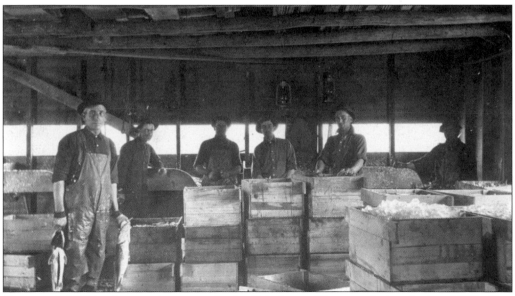

Commercial fishing became important in the Grindstone City area during the late 1800s. One such operation, run by John E. Upthegrove, took fish from Lake Huron, stored them in water-filled quarries, and then packed and shipped them out east to places like New York.

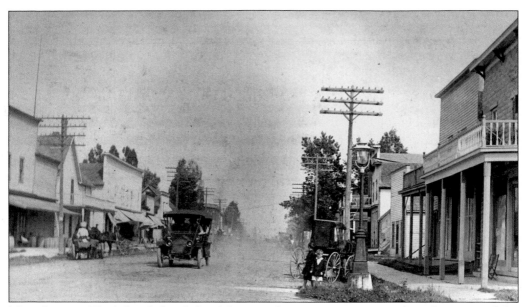

Main Street in Kinde bustled with local farmers who came to town to trade with stores and the grain elevators. Sleighs were used to haul people and cargoes in winter.

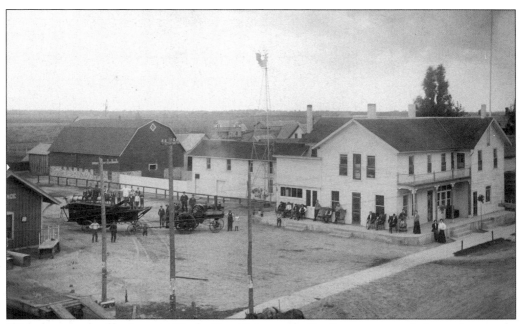

With the growth of business in Kinde, Port Crescent declined as an economic force. As a result, the Kennedy-McCoy hotel was moved from Port Crescent to a position next to the Farmer's Elevator in Kinde. In recent years, after several ownership changes, it was named the Wagon Wheel Hotel.

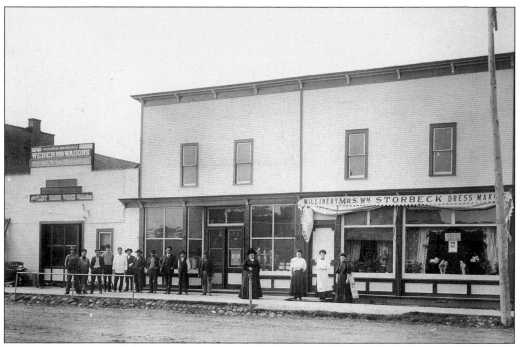

The old Weber Wagon business and Storbeck's Store are shown here around 1900.

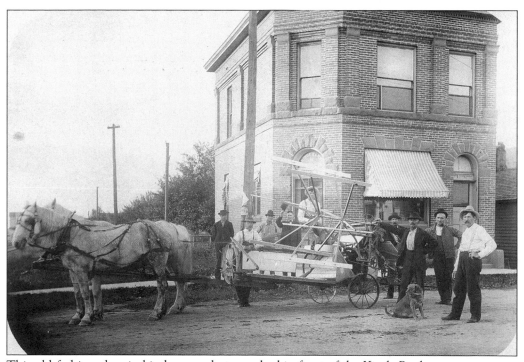

This old-fashioned grain binder was photographed in front of the Kinde Bank.

This photograph shows Main Street in Pinnebog before the streets were paved in the 1920s or 1930s.

This is the Hotel Pinnebog as it appeared in the late 1800s.

Seven
SEBEWAING

Before the Europeans arrived, the shores of Saginaw Bay were inhabited by Chippewa Indians. Dense forest made for good hunting and the islands and marshes along the county's southwestern shore were rich with fish and wildfowl. In 1845, Lutheran missionaries Johann J.F. Auch, Johann Simon Dumser, and Georg Sinke arrived on the banks of the Sebewaing River to evangelize the Indians. Four years later, Reverend Auch built the mission house at Shebahyonk (Shebeon) Creek where Edward Petit had established a trading post in 1829. In time, the Chippewa left the area and the European settlers, many of German descent, began clearing the fertile land for farming. The village became known as "Auchville" and then Sebewaing in 1857. The Great Fires of 1871 and 1881 destroyed large sections of the forest and opened the way for more rapid utilization of the land for farming. The Sebewaing River allowed for relatively large vessels to bring equipment and merchandise to supply the local settlers. Ships were built here. The Sebewaing Brewing Company was established in 1880 and the Saginaw, Tuscola, and Huron Railway arrived in 1882. A newspaper, the *Sebewaing Blade*, was established in 1890 and the Sebewaing Sugar Company was established in 1901.

John C. Liken established a general merchandise store that would become the largest in the county. Today, Sebewaing is the third largest city in Huron County. Farming and sugar beet processing remain the primary industries. Hunting and fishing in the area are as attractive now as they were to the Chippewa 150 years ago. (Photographs of Sebewaing and related captions are courtesy of Walter Rummel.)

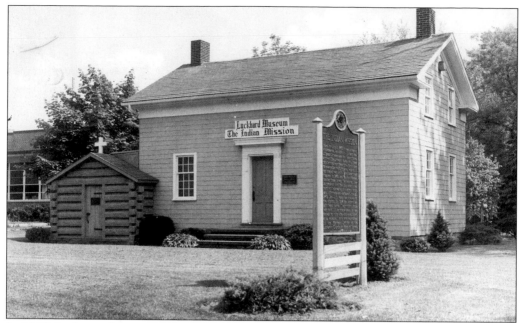

In 1845, Lutheran Missionaries Rev. Johann J.F. Auch, Rev. Simon Dumser, and Rev. Georg Sinke established a mission on the banks of the Shebahyonk (now the Shebeon) River to evangelize Chippewa Indians living in the area. The Indian Mission shown in this photograph was constructed by the missionaries in 1849 and was refurbished in the 1940s by Charles F. Luckhard. Today, it is preserved in its new location in Sebewaing as the Luckhard Museum. Rev. Auch later started the settlement called Auchville, which became Sebewaing in 1857.

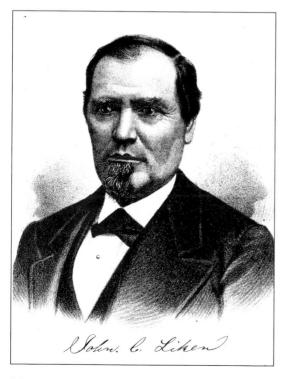

John C. Liken, one of Sebewaing's early businessmen, developed farmland, owned sawmills, a roller mill, and a general merchandise store in Sebewaing, along with stores in other towns in the area.

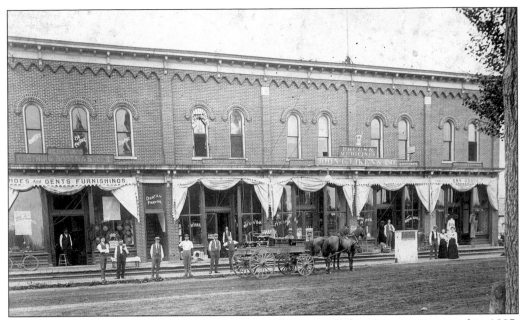

This is the John C. Liken and Company store in downtown Sebewaing as it appeared in 1897. Hardware, stoves, whips, medicines, gent's furnishings, dry goods, crockery, and groceries are advertised in the store windows and on the marquee—making this a truly "general merchandise" store.

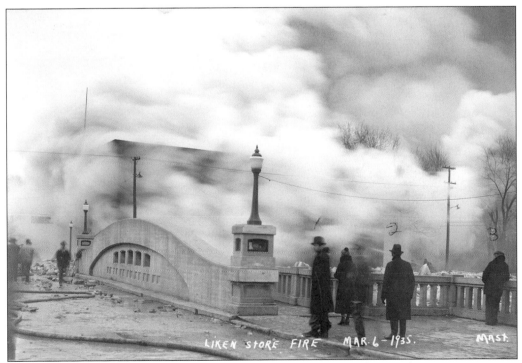

In 1935, the big Liken store came to a fiery end. The building and its contents were completely destroyed.

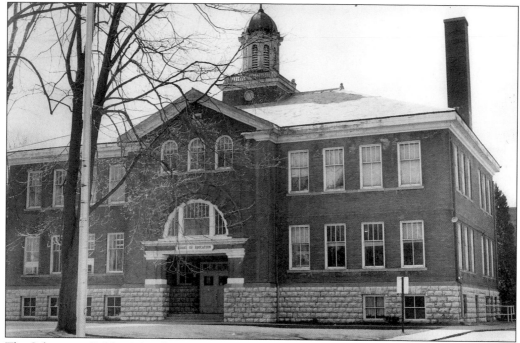

The Sebewaing Public School was erected in 1902 and served as the high school for many years.

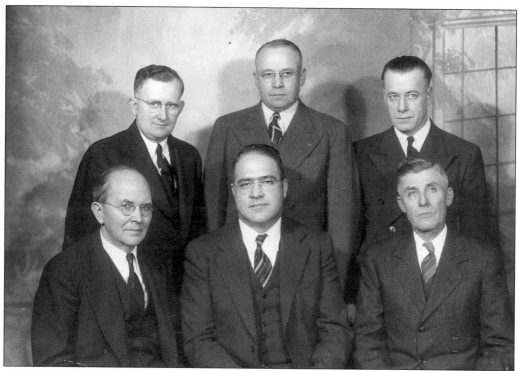

The Sebewaing Public School Board of Education in about 1938 is pictured here, from left to right, as follows: (front row) J.W. Scheurer, Supt. Charles Bush, and Fred Hintze; (back row) Arthur A. Mast, John Eisengruber, and Norman C. Fliegel.

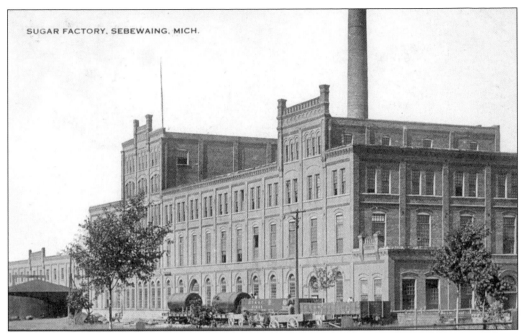

The Sebewaing Sugar Company plant was founded by William H. Wallace in 1901 and later became part of the Michigan Sugar Company in 1906. Sugar beets remain an important industry in the community today. The company's Pioneer Brand sugar is known worldwide.

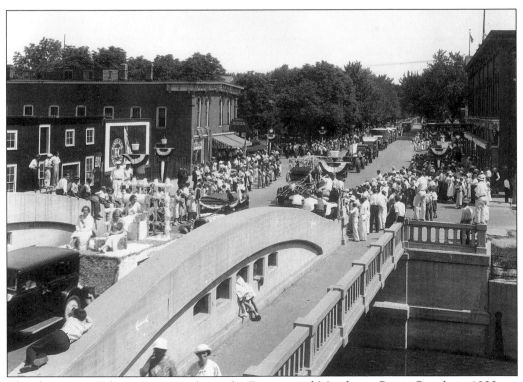

This downtown Sebewaing scene shows the Farmers and Merchants Picnic Parade in 1933.

The Sebewaing Brewing Company was formed in 1880 and was still in business in the early 1960s when these glass-lined vats were installed for aging beer. The brewery stopped production in 1965.

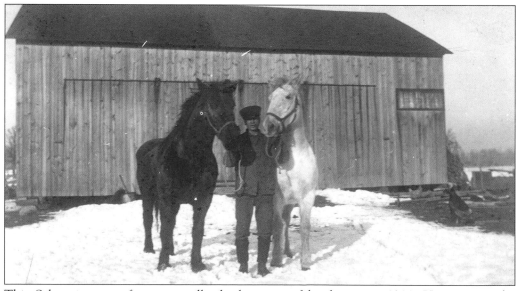

This Sebewaing area farmer proudly displays two of his horses in 1911. Horses were the mainstay of farming in those days.

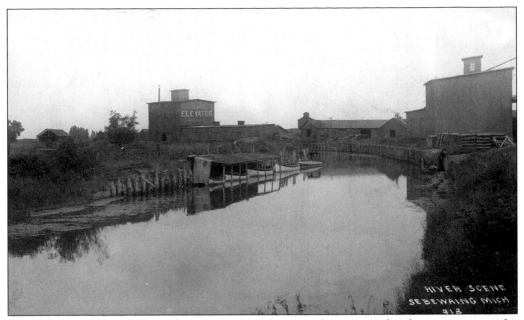

The Sebewaing River, shown here on a quiet day, was the center of early commerce in the town. In the early years, much of the merchandise and materials were brought in on lake steamers and sailing vessels.

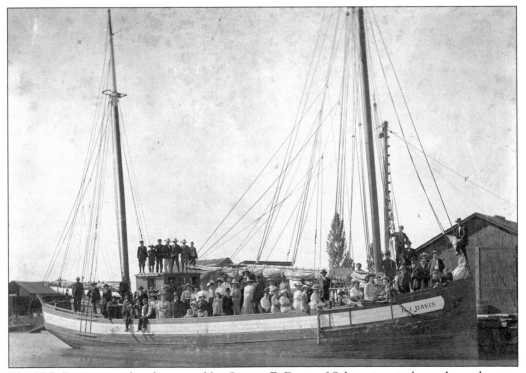

The *H.J. Davis*, owned and operated by George E. Davis of Sebewaing, is shown here about to depart on a Sunday school picnic to North Island in 1905.

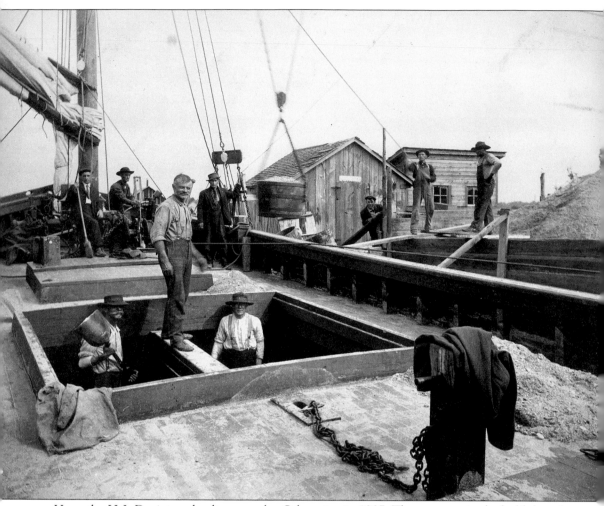

Here, the *H.J. Davis* is unloading gravel at Sebewaing in 1907. The two men in the hold shovel gravel into a bucket, which is then hauled ashore by hand. The man standing on the centerboard trunk is supervising the operation.

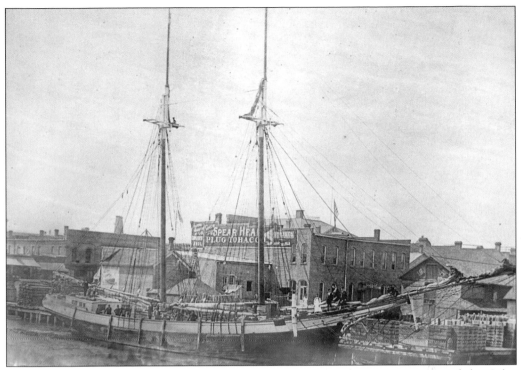

The *Hunter Savidge*, a typical two-masted Great Lakes schooner, was owned by John Muellerweiss and captained by Fred Sharpsteen, both of Sebewaing. The *Savidge* was tragically lost in a sudden squall off the tip of the Thumb in 1899 with the loss of five lives, including both Mrs. Muellerweiss and Mrs. Sharpsteen, who were along for a vacation trip.

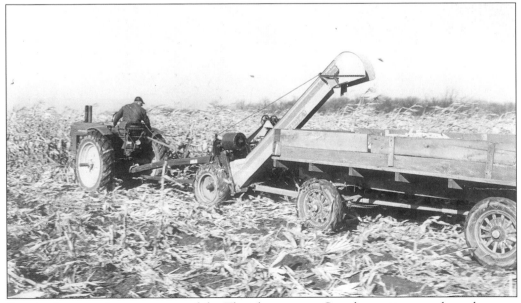

Farming is a most important part of the Thumb economy. Corn harvesting was slow when one small tractor and one harvester were used. However, they were a vast improvement over the horse-drawn equipment used through the early 1900s.

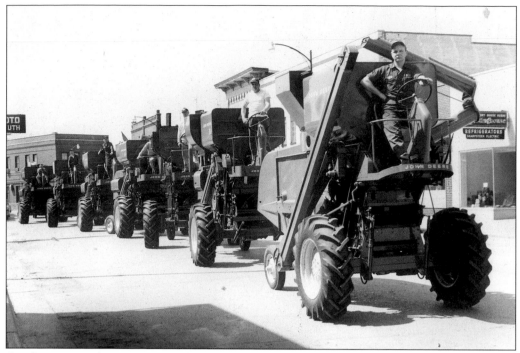

Combines were the next step in farm progress in the early 1950s, when the Gettel Implement Company of Sebewaing accepted delivery of these new models.

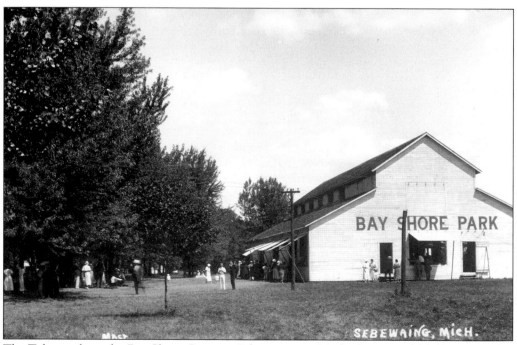

The Tabernacle at the Bay Shore Camp in Sebewaing is a Methodist-owned facility. It is larger today then ever before and is one of Sebewaing's greatest assets.

Nine
UBLY AND PARISVILLE

Ubly, the small town with the unusual name, is a thriving community on the Cass River in Bingham Township, Huron County. Incorporated as a village in 1896, Ubly is home to about 900 people who live and work in Michigan's Thumb area.

The village of Ubly was first called Sidon, (a Biblical name). Its next incarnation was Pagett's Corners, named after Alfred Pagett, who erected a general merchandise store in April of 1870 on land at the current intersection of M-19 and Main Street. He was soon followed by other merchants such as Alexander Pierce, Alexander Pike, Joshua Madill (Ubly's first village president), Benjamin Eilber, and others.

When the settlement applied for a post office in 1880, Mr. Pagett suggested the name "Ubley" after his hometown in the Bristol, England area. The application was approved by the United States government, but it was granted to "Ubly" with Mr. Pagett as the first postmaster. (Some believe the change occurred when a signpainter misspelled Ubley on the railroad depot.)

The first Polish settlers came to the nearby Parisville area as early as 1848 and the St. Mary's parish there had its beginning in 1852. Many people believe that Parisville is the oldest Polish settlement in the United States, but there is no factual historical data to support that claim, since early records were destroyed by fire.

The first families to obtain land patents in 1854 in what was to become Paris township were: Anthony Slavik, Francis Susalla, Francis Polk, and Thomas and Ambrose Smielewski. Born c. 1889, and raised and married there, three Parisville women lived to be over 100 years of age. They were Catherine Wrubel Partaka, who lived to be 107; Tillie Danielski Bukowski, who lived to be 104; and Gertrude Schornack Polowski, who lived to be 102.

Now, consisting mainly of homes with St. Mary's Church as their hub, Parisville at various times had hotels, farm implement dealerships, taverns, the Arcadia ballroom, a car dealership, gas stations, auto repair shops, and a grain elevator.

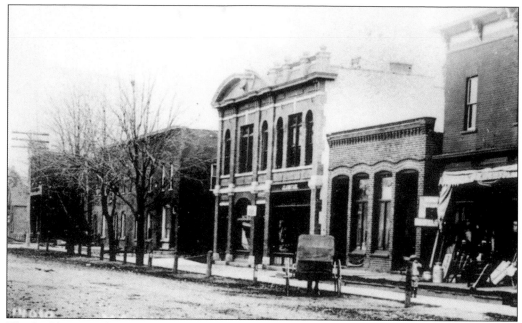

The building on the left is the Huron Hotel, in this 1910 photograph of Ubly's Main Street. The center buildings are the Sleeper Bank, the Armitage Harness Shop, and Pittsley's Saloon. The Citizen's Bank was established in the late 1890s by Albert E. Sleeper and Frank Merrill and was designated a Michigan Historic Site in 1996. This bank building and the old harness shop now house the Sleeper Public Library and Senior Citizen Center.

The Thumb Electric Cooperative (TEC) was organized in 1937 when a group of Huron, Tuscola, and Sanilac County farmers applied to the federal government for funds to locate a generating plant in Ubly to produce electricity for their rural farms. Part of Franklin D. Roosevelt's 1935 emergency relief program, the Rural Electrification Administration (REA) provided interest free loans to areas without electricity.

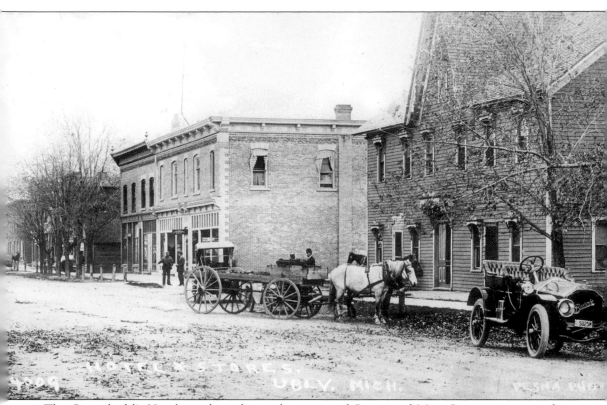

The Greyerbiehl's Hotel, on the right, at the corner of Queen and Main Streets, was one of three hotels in Ubly during the early 1900s. On the left are the Pierce General Store and Morris' Furniture and Mortuary. The Masonic Temple was upstairs over the mortuary. The hotel site is the current Kumaus Plumbing & Heating business while the former general store is vacant. Angelina's Eatery occupies part of the old furniture store.

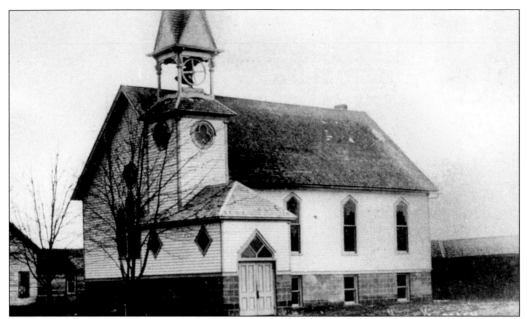

The United Methodist Church is shown here in 1913. The Ubly Methodist Church was erected at its present location in 1882 after the fires of 1881 destroyed the church that the congregation had just begun building. A basement was added and the entrance moved to the eastside around 1910.

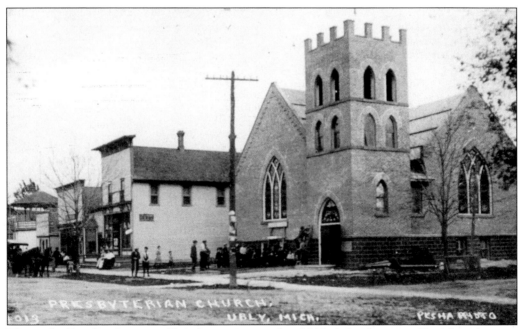

This is the First Presbyterian Church as it appeared in 1913. A Presbyterian Church and manse were constructed on North Washington Street in 1882–84. This church was moved to its present location in 1908. In 1910, a north wing and stained glass windows were added, and the exterior was bricked. The Reverend Thomas Hurd was the first pastor in the new building. Crorey's Drugstore and the Ubly bandstand are visible on the left, in this photograph.

The St. John the Evangelist Catholic Church is shown here in 1915. The first Catholic Church was built on North Washington Street on land donated by Michael Murphy. Under the supervision of Fr. Anthony Ternes of Port Austin, the church was constructed of stone hauled to the site by oxen. A rectory was built in 1913 and the church was enlarged. Because a significant number of the parishioners were Polish, services were held in both Polish and English until 1947. The current church was constructed in 1939, under the leadership of Reverend Fr. Kilar.

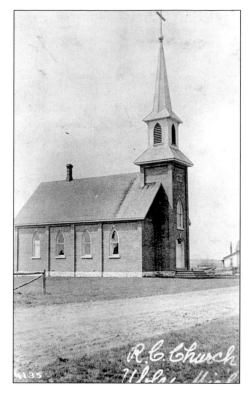

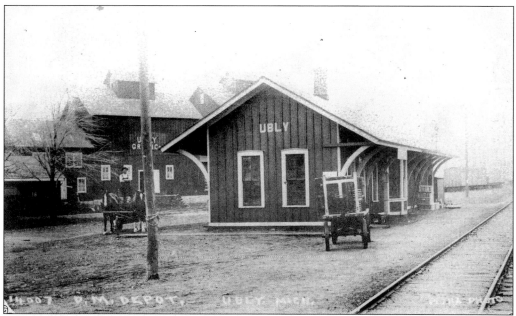

The Port Austin and Northwestern Railroad arrived in Ubly in 1881–82. The first tracks were narrow gauge. By 1904, the railroad was owned by the Pere Marquette Railroad and later the Chesapeake & Ohio. The depot was sold in the late 1970s and removed from its east-end site. The land near the depot was so muddy, especially in the spring, that local men had to push logs down into the mud and cover them with dirt so they could drive their wagons up to the depot.

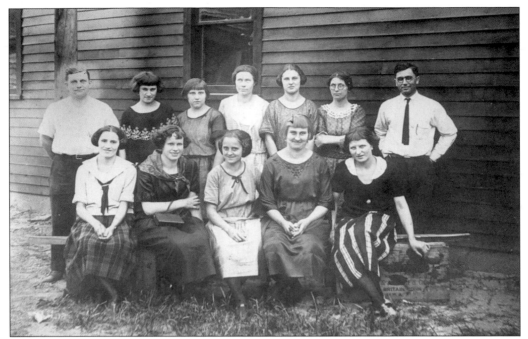

Pictured here are the employees of the Huron Overall Factory in about 1923. The factory manager was Marshall Palach. The factory was organized in 1922, and at its peak produced 50 pairs of overalls a day. The large bolts of denim were shipped to Ubly by train, where workers cut the material and assembled the overalls—which sold for $3.50 a pair. The factory was in the building where Dr. Fucinari's office is located today.

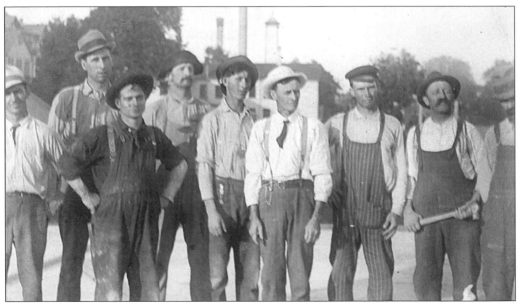

Getting goods to the train and delivering incoming articles to local merchants were important jobs for this group of workers called "drayers". They also provided transportation for the "drummers" (salesmen) to any of several nearby hotels and delivered mail to the Main Street Post Office.

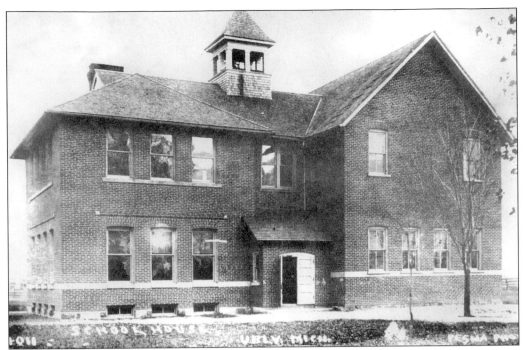

A red brick schoolhouse was built west of the Cass River, south of the present Ubly Community School, in the late 1890s for grades one through eight. Students wishing to attend high school usually boarded with families in Bad Axe and attended high school there. The north wing was added in 1904 and education was offered through grade ten. The class of 1922 was the first to graduate from 12th grade. The present school building was completed in 1937, with additions constructed in 1953, 1966, and 1993.

The former Bingham Township Hall, located on Pike Street in Ubly, was used as a voting and meeting place until 1976, when a new hall was erected on the corner of Pierce and Garfield Streets. The new building also houses the government offices for the village, the township ambulance service, and the fire department.

Located on Pike Street, this small brick building was erected as a "lock-up" for the village. James Sparling was the first town marshal, pound master, and street commissioner—which meant that he was to take care of stray cattle and loose horses as well as errant citizens. These jobs paid him $15.00 a year plus all the fees he collected. The building was later enlarged to house the village fire-fighting equipment and council offices. The pound occupied the adjacent grounds.

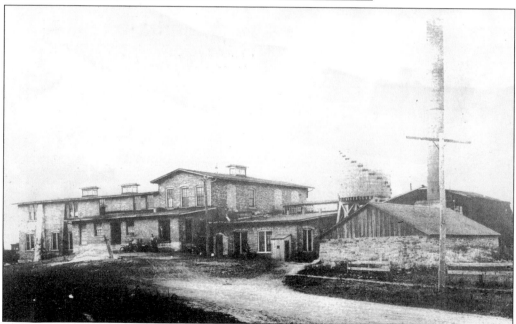

The D.B. Hand Condensed Milk Company occupied this building until 1906, when it was purchased by the Page Milk Company. In 1919, the Nestle Milk Company bought the business, which made evaporated milk and later, sweetened condensed milk. The company had its own water supply and electrical power. For a time, women workers cut tin by hand to make the cans the company needed. The Nestle Company ceased operation in 1971 and the Lyntex Manufacturing Company now occupies the building.

Ten

WHITE ROCK

White Rock stands alone north of Detroit on the earliest maps of the Dutch, French, and English explorers. The town was named after a huge limestone boulder, venerated by the Indians as a Manitou, situated just offshore in Lake Huron. The rock was large enough to accommodate six to eight sets of square dancers.

Indians gathered at White Rock and so did the earliest explorers and trappers. White Rock became the eastern boundary of the treaty of the Northwest Territory of 1807. It was the first settlement in what would become Huron County and the first Red Cross project outside of New York for the survivors of the fire of 1881. The fabled village of White Rock was advertised worldwide.

The town soon became an important early trading center in the Thumb; with two sawmills; an early salt brine company; and a harbor with a one thousand foot-long dock. The present White Rock school was constructed in 1909 and served the community until 1968. Today, it has been restored and is the White Rock Museum.

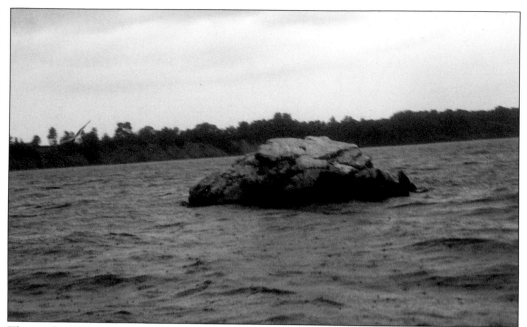

This is the White Rock Stone as it exists today. It was once a smooth limestone boulder that was venerated by the Indians and mentioned in the journals of early explorers from Father Marquette to surveyor Henry Rowe Schoolcraft, who noted Indian offerings of tobacco and weapons on the White Rock stone. It was nearly destroyed by the Army Air Corp, who used it as a practice target for bombing and strafing during World War II.

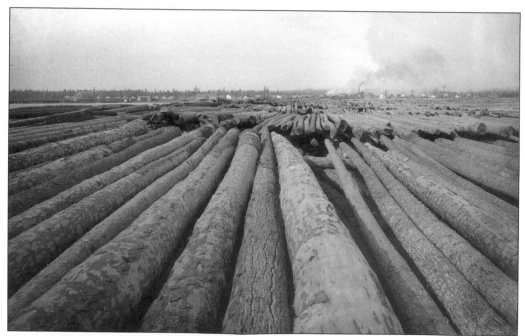

This is a view of the Mill Reserve and bay at White Rock, choked with logs waiting for White Rock's two sawmills to turn them into lumber. The lake bottom at White Rock still gives up "first saws off the log."

116

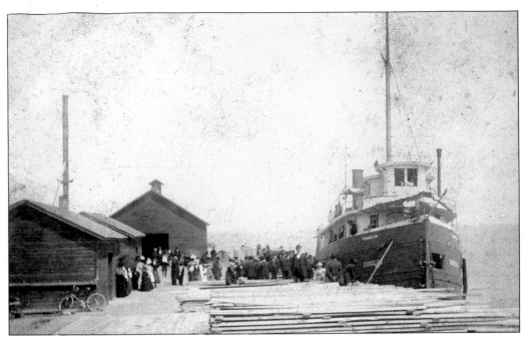

The White Rock dock and others like it preceded a road system. The first Polish settlers in America disembarked on the White Rock dock and established Parisville ten miles to the west. The one thousand foot-long dock consisted of log cribs filled with stones donated by farmers from their fields. The final 300 feet were made of driven virgin white pine pilings. Some of these "spiles" can be seen when the lake water level is low.

Alexander Lindsay, an educated Irish immigrant and pioneering White Rock resident, sold his homestead located on the "hogs back" of the Cass River, and bought five businesses in White Rock, which unfortunately burned the next morning in the Great Fire of 1871. He later owned the stagecoach line that serviced the Thumb from Detroit. He bought each of his five children a farm and he owned the Ponchartrain hotel in Detroit.

With their sailing future in the background, life-long friends Captain William Lindsay and Captain Fred Meno frolicked as boys on White Rock's rocky shoreline. Both became Captains. Captain Lindsay was one of the few shipmasters to bring his vessel safely through the Great Storm of 1913.

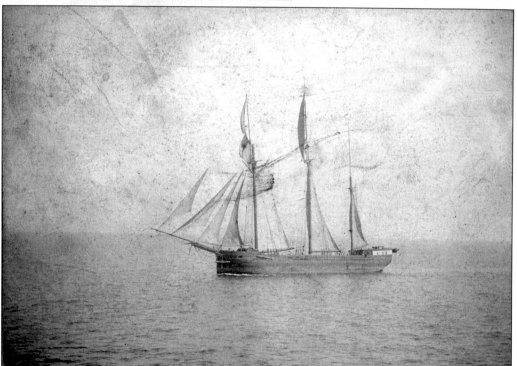

This is one of Captain Lindsay's vessels, which is seen under sail off the coast of Huron County. Sailing vessels like this one carried the people and commerce of early Michigan, particularly during the transition from richly forested wilderness to farming and later manufacturing.

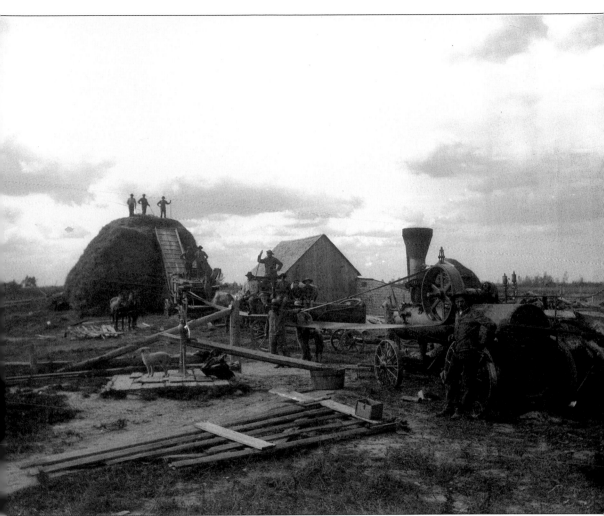

This photograph shows a threshing bee in White Rock Township. Tractor and steam-driven threshing machines represented a major leap forward for agriculture. Likewise, White Rock Township was merged for efficiencies sake with Sherman Township in the early 1900s.

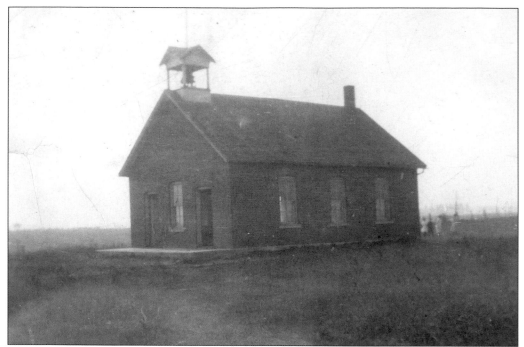

The White Rock School, built in 1909 after an earlier two-room school burned, stands alone in 1910 on land still barren of trees from the two great fires that swept the Thumb in 1871 and 1881.

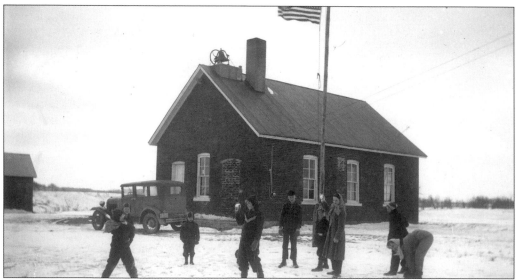

The White Rock School is shown here in September 1946, and still had only small brush growing in the distance as a result of the 1881 fire that burned for three days and three nights. Mrs. Ruth Will was the teacher. Her car is in front of the school. The kids thought the car was ancient, but she drove it from Harbor Beach to White Rock every school day and picked up some of the students on the way. Present in the picture are, from left to right: Sheila Cowper, Jim Pawlowski, Bob Pawlowski, Norma Edwards, Bill Edwards, Roland Edwards, Darlie Anderson, Marjorie Edwards, and Jo Ann Clor.

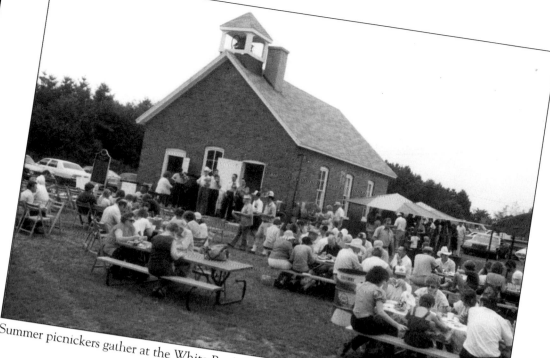

Summer picnickers gather at the White Rock School Museum on the first Sunday every August.

w of Lake Huron, was built by Sam
, gas station, barbershop, and pool
General Store, the "Punkin Center,"
971. Dance tickets on opening night

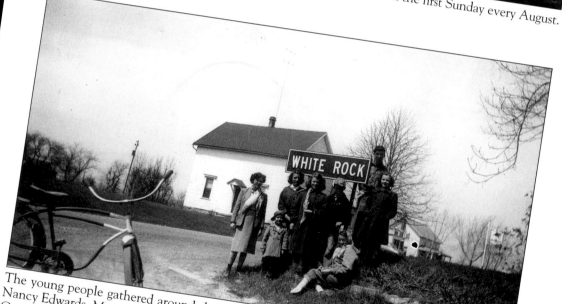

The young people gathered around the White Rock sign are, from left to right: Lois Cowper, Nancy Edwards, Marjorie Edwards, Norma Edwards, Roland Edwards, William Edwards, Sheila Cowper, and (seated in front) Darlie Anderson. Rose and Ernie Hall's place, Rose's Lunch, stands in the background. Further back stands Alexander Lindsay's home, which was built by the Red Cross to aid victims of the fire of 1881. This was the first Red Cross project conducted outside New York City.

's infamous Purple Gang. A man was shot and
te Rock lady married one of the richest men in
was author John Steinbeck. Could one of these

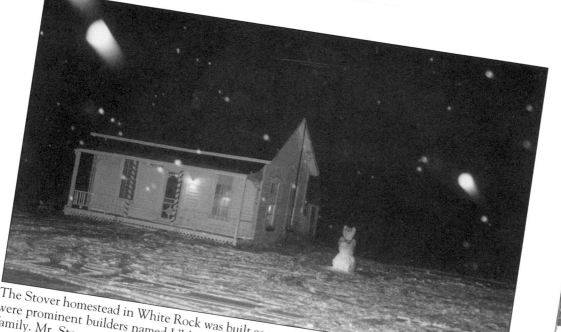

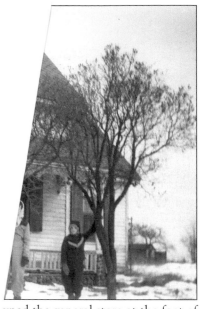

The Stover homestead in White Rock was built as a wedding present by the bride's parents who were prominent builders named Uhl. The Stovers were related to the Stover Candy Company family. Mr. Stover was a "horse doctor" who ran the livery for the stage coach line and saved a few human lives over the years as well. Uniquely, this home has been solely owned by five generations of Stover family women.

...wned the general store at the foot of ...It was once home to the second wife ...divorce and became best friends and ...ge Wilson of Meadowbrook Hall and

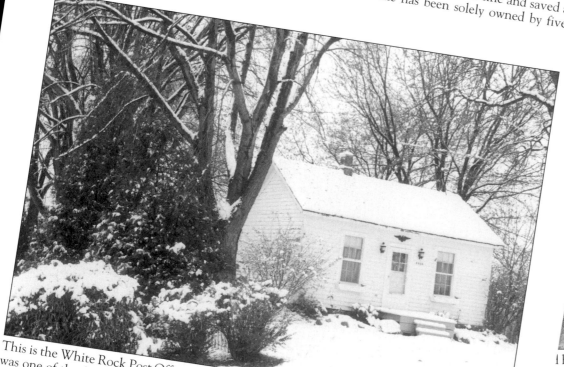

This is the White Rock Post Office, which was restored by Marilyn Edwards. Alexander Lindsay was one of the first postmasters.

...d here with a fine team of horses. Horses followed ..."Daddy" Stocks was a captain in the Union Army ...rs. Like many White Rockers, he ventured further ...ets while others left their names on the Rocky

124

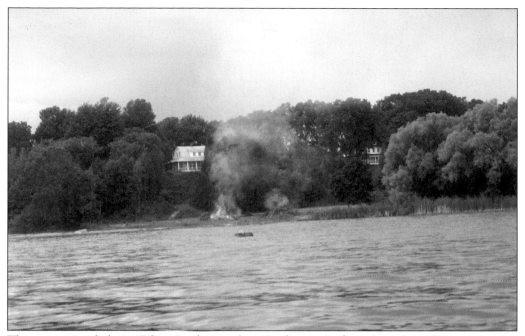

The navigation light at White Rock was white. In the 1800s, fires along the White Rock shore at night were sometimes mistaken for the Forestville light, which was red, and consequently resulted in shipwrecks. Forestville's harbor could only be approached from the north but White Rock can only be approached from the southeast.

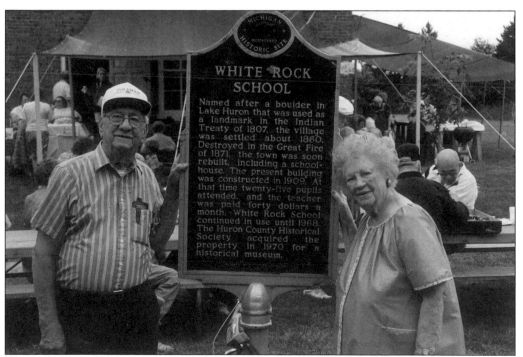

Joe Hanna and Lucille Hanna McCollough, two former White Rock school students, are shown here standing next to White Rock's state historical marker.

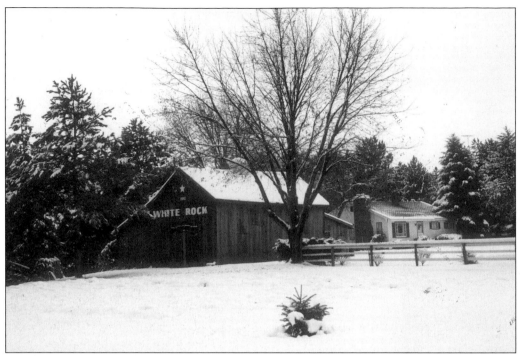

This barn was built at White Rock in 1886 by Captain William Lindsay and is one of the few original White Rock buildings that remain today.

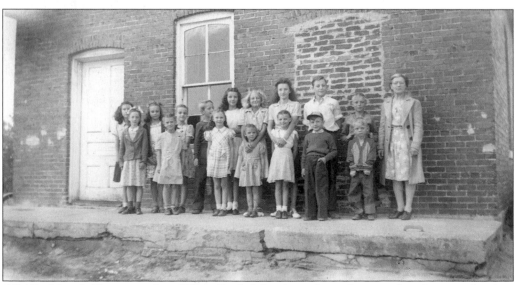

All 15 of the children attending White Rock School are shown here, in this photograph taken in 1946.

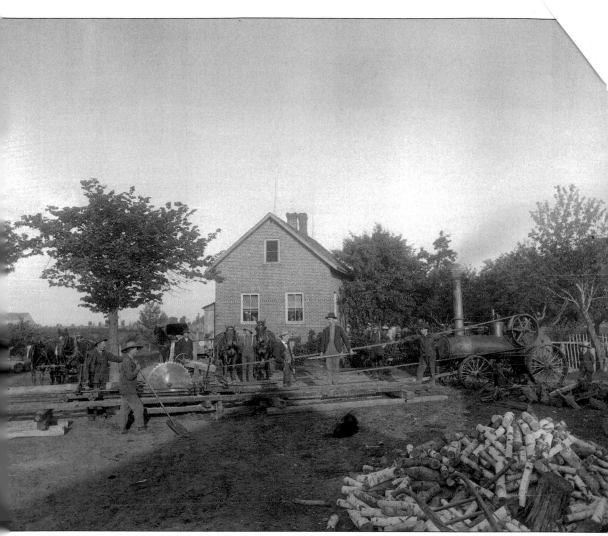

Sawing logs was a neighborhood affair as home sawmills replaced the large company mills when lack of timber for cutting or for fuel forced them out of business. The salt block company at White Rock suffered a similar fate, as its supply of wood for fuel to boil brine water and run steam engines ran out.

Acknowledgments and Bibliography

Acknowledgments

The Huron County Historical Society wishes to thank all those whose efforts have made this publication possible especially the member chapters.

Bad Axe Historical Society
Bay Port Historical Society
Caseville Historical Society
Elkton Historical Society
Grindstone City Historical Society

Harbor Beach Historical Society
Pigeon Historical Society
Port Austin Historical Society
Ubly Historical Society
White Rock Historical Society

The County Historical Society also wishes to thank:

Walter Rummel, Sebewaing, and James Hunter, Port Hope, for the use of their photographs and historical commentary regarding Sebewaing and Port Hope; Theresa Glass, Bill Denbrock, David A. McDonald, Janice Prill, Robert Quinn, The Frank Murphy Museum, Donald Weiss, John L. Wagner, and Carol Messner for the use of photographs from their collections; and especially the editorial team of David A. McDonald, Cliff and Ruth Willett, Christine Clancy, Leonard Watchowski, Catherine Kennedy, Grace Donahue, and Leonard Bumhoffer, who organized and edited all of the material and photographs submitted for this book.

Bibliography

Boyer, Dwight. *Strange Adventures of the Great Lakes*. New York: Dodd, Mead & Company, 1974.

Hey, Chester A. *Huron County History Illustrated*. Bad Axe: Publisher unidentified, 1932.

Hey, Chester A. and Norman Eckstein. *Huron County Centennial History*. Harbor Beach: Harbor Beach Times Press, 1959.

Luckhard, Charles F. *Faith in the Forest*. Sebewaing: C.F. Luckhard, 1952.

Sodders, Betty. *Michigan on Fire*. Alpena: Thunder Bay Press, 1997.

Soini, Paul. *Bad Axe Golden Jubilee*. Bad Axe: Huron County Tribune Press, 1935.

Woman's Club, Harbor Beach. *Harbor Beach 1837–1976*. Harbor Beach: Publisher unidentified, 1976.